Michelangelo

'Because a sculptor's work is so slow . . . there is not so much time to read serious books really thoroughly, but this is one I hope to read at least once, if not twice, more. I think Adrian Stokes has made a new, deep and penetrating contribution to present-day art criticism.'

Henry Moore

'No one else has so pondered the implications of the fact that a capacity to understand art is dependent on a capacity to understand human beings. Michelangelo's artistic personality . . . has been profoundly read. It will be difficult to be content again with any view that does not look into its depth, or with one which does not see the man's life, his visual works and his poetry together.'

Lawrence Gowing

'Adrian Stokes (is) a critic whose work is not as well known as it should be . . . *Michelangelo* is not a long book, but it is so tightly packed with meaning that it must be read more than once – I myself have read it three times, and with each reading have found increased understanding and pleasure.'

Herbert Read

'. . . this book is one of the few written by an art critic in which the processes underlying artistic creation are described with deep psychoanalytical insight.'

H. Sydney Klein, International Journal of Psychoanalysis

Adrian
Stokes

Michelangelo

A Study in the Nature of Art

With a new introduction by Richard Wollheim

London and New York

First published 1955
by Tavistock Publications Limited

First published in Routledge Classics 2002
by Routledge
11 New Fetter Lane, London EC4P 4EE
29 West 35th Street, New York, NY 10001

Routledge is an imprint of the Taylor & Francis Group

Typeset in Joanna by RefineCatch Limited, Bungay, Suffolk
Printed and bound in Great Britain by
TJ International Ltd, Padstow, Cornwall

British Library Cataloguing in Publication Data
A catalogue record for this book is available from the British Library

Library of Congress Cataloging in Publication Data
A catalog record for this book has been applied for

ISBN 0–415–26765–X

CONTENTS

List of Illustrations

AUTHOR'S NOTE

The author acknowledges a very considerable debt to Professor Lawrence Gowing who was good enough to comment upon an early draft; to Professor E. H. Gombrich also, who so kindly read a later draft; to Mr. and Mrs. J. C. Palmes for their prompt and learned help; to his fellow-members of the Imago Group who discussed with him a part of the book.

His thanks are due to Mr. Bernhard Berenson and his librarian who accorded him the privilege to read in the Berenson Library, Settignano; to the librarian of the Warburg Institute, London; to Her Majesty the Queen for permission to reproduce drawings in the royal collection at Windsor; to the Trustees of the British Museum in regard to the reproduction of drawings in the Print Room. Acknowledgement is made to Messrs. Cape for permission to reproduce the poem by Robert Frost on page 113.

Plates 1, 13, 15, 16, 17, 19, 20, 23 are after photographs by Alinari.

Plates 10, 11, 14, 22, 23, 24, by Anderson.

INTRODUCTION

by Richard Wollheim

In his lifetime Adrian Stokes achieved the kind of fame that has nothing to do with success. No book of his sold more than five hundred copies, but his prose, fiercely difficult by the standards of the time, seized the imagination of some of the most interesting and creative minds of his age. They included sculptors, painters, poets, architects, critics of the arts: Henry Moore, Barbara Hepworth, Ben Nicholson, Henry Reed, Colin St John Wilson, William Coldstream, Elizabeth Bishop, Lawrence Gowing, Andrew Forge; the list could go on. Since Stokes's death in 1972, at the age of seventy, this has changed. His name is much more widely known, but there has been little effort to keep his books in print, and in consequence they are known mostly by hearsay. They have become as reclusive as their author was in life. They are 'rare items' in booksellers' catalogues.

Michelangelo is one of the least-known of Stokes's books. Yet it is at once innovatory in Michelangelo criticism, and, as its history of publication reveals, a turning-point in Stokes's work. It was the first of his 'Tavistock books'.

In the autumn of 1926 Stokes was on holiday in Rapallo.

He had behind him two youthful books on the prospects for civilization, and he was now living in Italy, having succumbed to its spell on New Year's Eve, 1921/2, as he crossed the Alps for the first time. He had chosen to live in Venice, and he had spent the summer of 1926 travelling in northern and central Italy, in the course of which he had discovered the magic of the Tempio Malatestiano at Rimini.

In Rapallo he found recreation in playing tennis with the tennis coach, until, wanting to extend his game, he asked if there was anyone amongst the local inhabitants who spoke English and liked to play tennis. Yes, he was told, there was a man living in the hills called Pound. And who was Pound? The coach chose his words carefully, and, whether or not he thought of the phrase, it stuck in Stokes's mind. Pound, he was told, was – note, not is, but was – a has-been. Stokes liked the idea. When Stokes and Pound met, Pound was forty, something of an exile from literary worlds he had once dominated, but still a force to be reckoned with, and Stokes was twenty-three, with striking looks, something of a visionary, and irresistibly shy. A powerful bond grew up between the two men, cemented by a common fascination with the Tempio, with its architecture, its sculpture, and – though this was later to be the point on which they parted ways – the dark personality of its creator, the tyrant Sigismondo Malatesta. To seal their friendship, Pound told Stokes that he had a friend in London called Eliot; Eliot was a publisher, and he would write to Eliot and tell him that he should publish ten books by this young man who had evidently something to say. Though Stokes was always a slow writer, and was not someone to be hurried on by the fact that he had an interested publisher, this chance happening was the origin of his first lot of books, his 'Faber books'. Eliot must have kept his promise, for there were in fact ten of them, starting in 1932 with The Quattro Cento, and terminating in 1951 with Smooth and Rough: two more picture books followed in the Faber Gallery series. The Faber

books are the works of an aesthete *de pur sang*. There is, of course, much variety within them. The earlier books are, for the most part, grounded in careful observations of works of art, and go on to present broad and arresting ideas about the place of art in our lives, the later books use autobiographical fragments to show how various aspects of art reverberate with early experience. And the scope of the argument enlarges. If, in the first two books, Stokes confined himself to sculpture and architecture, subsequent books discuss painting, as well as his new enthusiasm: the ballet as he had got to know it through the great Diaghilev seasons of the late 1920s. A careful reader of the present book will observe a footnote to Part II, in which Stokes talks of 'classical ballet, sole inheritor in our time of Renaissance art'.

However, there is a theme that runs through the Faber books and holds them together. It is the distinction between two modes in which visual works of art can be executed. Though Stokes had explicitly rejected the terminology in *The Quattro Cento*, by the time he came to write *The Stones of Rimini* he referred to the two modes as *carving* and *modelling*. In the case of each mode, the external relations in which the work of art stands to the spectator and the internal relations in which the constituents of the work stand to one another are mirror images of each other. Or should I say 'appear to stand'? For both sets of relations are ultimately a matter of an effect that the work establishes in the mind of someone who looks at it attentively.

A work in the carving mode exhibits a distinctive 'out-there-nesss', or independence from the spectator, while the forms of which it is composed blend into an unassertive, an uncompetitive, harmony. By contrast, a work in the modelling mode tends to envelop, or merge with, the spectator, while the forms that make it up are set over against one another, and can be reconciled only in an arbitrary, or what Stokes calls a 'masterful', way.

The carving/modelling distinction works in Stokes's thinking in much the same way as the *linear/painterly* distinction in

Wölfflin's famous system. In the first place, each polar term collects to itself a number of what are held to be integrally related characteristics. So, just as the linear in Wölfflin is associated with the cultivation of what he calls the *plane*, *closed form*, and *absolute clarity*, so carving in Stokes is associated with what he calls – and sometimes the terms are used idiosyncratically – the *love of stone*; *mass* or *mass-effect* (as opposed to *massiveness*, which is a characteristic of modelling); *immediacy*, or what can be taken up with the 'quickness of the perceiving eye'; and, hardest of all to grasp, the *emblematic*, by which is meant something like the expressive. Secondly, despite the use of the term 'linear' by one writer, 'carving' by the other, and their natural connotations, both contrasts are taken to apply across the range of the visual arts.

If all this is effected by the completion of the Faber books, two new developments occur with the change of publishers to Tavistock.

In *The Quattro Cento* and *The Stones of Rimini*, the carving/modelling distinction is used in a highly normative fashion. Carving is the true path of visual art, and the greatest artists of our canon are to be found amongst those who are rightly, if not always literally, thought of as carvers: Piero, Agostino di Duccio, most but not all of Donatello, Bellini, Piero della Francesca, Giorgione, Brueghel, Vermeer, Chardin, Cézanne. But gradually this insistence upon one tradition modifies, and virtue is also found in a form of art that lures the spectator into its ambience. However, as *Michelangelo* makes clear, it would be some time before Stokes was ready to announce these as independent or alternative ways of making art. In the present study, modelling is no more than ancillary to carving. Michelangelo, in winning the figure from the stone, allows the stone to intimate the block from which it has emerged. Stokes describes Michelangelo's achievement thus: 'As well as contriving so that a markedly individual shape should emerge, a near and loved thing such as the fifteenth century conducted to the light from a rich medieval

soil, he partly re-interred the new-won finite world, no less than the antique, just dug from the Roman ground, in the homogeneous block.' 'Oneness', or the merging with the work, is a value, but it is a value that is envisaged solely as an accompaniment to that of the free-standing object, or what Stokes calls 'individuality'.

Along with this gradual transvaluation of the modelling mode vis-à-vis the carving mode went the attempt to deepen the account thus far offered of the psychological significance of the two modes. The background to this new move is the psychoanalysis that Stokes entered into with Melanie Klein, which ran through the 1930s, and was briefly revived after the war at the time of his remarriage. This represented an old interest. Stokes told me that his interest in Freud was first aroused by a fellow schoolboy, called William Robson Scott, who was later a distinguished historian of German culture, and Stokes read widely in the literature of psychoanalysis in the 1920s. However, while in analysis, Stokes refrained from writing about psychoanalysis, even though he might be suspected of keeping a place warm for it at the heart of his aesthetic theory. Then, in the semi-autobiographical writings, Inside Out of 1947 and Smooth and Rough of 1951, the topic creeps in.

The form that the new project took was the linkage of the two modes with the two earliest phases of life as these were reconstructed more specifically by Klein than by Freud. The modelling mode was thought to parallel the earliest phase when the infant still feels itself to be symbiotically related to the mother, and its world is constituted by part-objects, some of which are benign, and some deeply persecutory. The carving phase was thought to parallel the next phase when the infant gains awareness of the mother as an independent object, which persists through time, and is not dissoluble into elements extravagantly good or extravagantly bad. What comes with this awareness is a new sense that the figure so often attacked is the

same as the figure so deeply loved, and a desire to repair the damage makes itself felt within the infant.

But, if these linkages are accepted, how do, or should, they enter into our experience of art, or explain its power?

Initially Stokes invoked these linkages only to account for the perennial appeal that certain works of art hold for us. They trigger, he suggests, powerful memories of an archaic past, which in itself is no longer fully intelligible to us, but how they are in a position to do this is something of a mystery. However, by the time we arrive at *Michelangelo*, the theory is emboldened, and now it is proposed that the aura of infancy that the greatest works of art carry with them can be attributed to the deposits of early experience left in the artist's psychology, upon which he is able to draw in the moment of creation.

No one who had completed a lengthy personal analysis would be likely to underestimate the complexity of trying to pair off adult manifestations with infantile experience in such a way that one could be thought to explain the other. At the beginning of Part III of the present study, Stokes confronts the issue with engaging frankness. He reminds us that we are, in the case of Michelangelo, fortunate enough to have, in the contemporary biographies, and also in his letters and poems, something that suggests the emergent armature of his personality. But he also reminds us that works of art are not silent about their makers. Stokes listens carefully to the sweep of Michelangelo's brush.

One of the fascinating aspects of the present work is the delineation, embedded, like a Rembrandt portrait, in deep chiaroscuro, of this uneasy depressive genius: the grown son who is obliged to mother the father whom he resents, the young orphan who desires nothing more than to usurp the place of the dead mother whom he loves, the great creator who writes, 'I live on my death', and again, 'I tell you there is no better approach to sanity and balance than to be mad'.

August 2001

Part I

Introductory

1

GENERAL INTRODUCTION

It is wise to introduce the reader with affability to an author's didactic purpose. In the present case, however, Michelangelo will hardly be mentioned: unfortunately, the introduction must help to shed on the further subject-matter a light which the book itself was designed to radiate. I must start with the dim light of abstraction, whereas the text that follows is at least more robust.

It was said before Freud that the child is father to the man. No one will have objected to so vague an insight. Similarly to-day, under the pressure of Freud, some of our more successful intellectuals have been crying *Angst, Angst*, making homely a content that could otherwise lead them to the unfamiliar. Their generalizations will appease or banish detail: and so, our compliance with the present actuality of infantine, crucial images will be no less unfamiliar than before.

Such matters do not disturb the reader in the sections that follow this. Part III discusses certain aspects of Michelangelo's poetry in the light of arguments developed in Part II which treats of Michelangelo's works in visual art. Part II is the difficulty,

where I outline a theory concerning attitudes that determine the creation of form in the arts. The idea is simple: however, it is coupled with psycho-analytic conceptions both unfamiliar and subtle, though I do not attempt to convey their system, nor their refinement except occasionally with regard to the matter in hand. (I can only hope I have not subjected them to distortion in this way.)

Thus, this theory of form is tied up with psycho-analytic attitudes that may seem to have no bearing on art. Yet the alliance between some of the conclusions of this science and æsthetic experience has not occurred abruptly. Indeed, for more than twenty years I have emphasized the 'otherness' which now appears again, the 'out-thereness' of the work of art. A generic distinction I made between carving and modelling (1934 and 1937) has close connections with the present theory. It is possible that the carving-modelling distinction was already associated with the lengthy experience and study of psycho-analysis: if so, the influence was not overt: the one department of experience has not been applied summarily at any time to the other: on the contrary, æsthetic appreciation and a modicum of psychological awareness have gradually become inseparable; they mingle in the present book at the instance of Michelangelo's works. In the light of his art, I offer also some remarks about his life.

Having warned the reader, I must assure him that this is a book of æsthetic appraisal devoted to Michelangelo and humanist art, to an unique quality of humanist art. Unfortunately, it is impossible for me to attempt to support beyond the immediate text, to argue the validity of the psycho-analytic conceptions— some of them hotly disputed among analysts themselves—that are implicated. The reader with sufficient interest must refer to the literature of the subject, in particular to *Contributions to Psycho-Analysis* by Melanie Klein (1948) and to *Developments in Psycho-Analysis* by the same author and others (1952). (Melanie Klein, Dr. P. Heimann and R. Money-Kyrle are the editors of a

compilation entitled *New Directions in Psycho-Analysis* (Tavistock Publications), to which I have contributed a tentative paper on form in art, presenting the theory of this book in more specific terms.)

I have needed in rare instances to use psycho-analytic terminology. The following are the principal terms employed.

It is almost a common, though perhaps regrettable, usage to speak of 'guilt' in indicating the sense or feeling of guilt whether justified or unjustified ... I have occasionally mentioned 'depressive anxiety' and 'persecutory anxiety'. The latter refers to the anxiety of being persecuted, the former to the anxiety caused by fear that what is good or loved may be endangered or lost, leading possibly to depression. (Fear of our own aggression is the prime factor in both cases.) The wide application of these alternatives originated in the work of Melanie Klein who traced them to the early months of infancy, to the first weeks in the case of persecutory anxiety. . . . It is possible that the word 'object' when applied to persons is a psychological usage: the expression 'internal object' or 'internal person', however, which I must use, requires brief comment. The feeding infant incorporates in fantasy both the objects that give him satisfaction and those that give him pain, as soon as he is aware of anything in the world to be outside. Thus there are built systems, corporeal in origin, of what is 'good' and what is 'bad', the mirror of our own inextinguishable hate and aggression: the well-known concept of the super-ego is based upon this complicated and enduring process of incorporation or introjection, alternating with projection. . . . I think that is all, except I now use descriptively Freud's adopted phrase, 'the oceanic feeling', the sense of oneness with the universe, which he derived, in one instance, from the feeding infant's contentment at the breast . . .

Art, I believe, as well as love, offers us some share in the oceanic feeling. Yet, with the phantasm of homogeneity, of singleness, the lover experiences in the beloved her singularity:

she is the acme of emotive otherness, the essence of object. Now, this appreciation of the object's separate sufficiency united to a sense of identity with the pulse of things, prefigures, in my opinion, the sentiments that works of art in general stimulate in us, whatever their subject-matter or their occasion. 'An element of self-sufficiency'—I quote from page 72—'will inform our impression of the whole work of art as well as of turned phrases and fine passages. The poem, the sum-total, has the articulation of a physical object, whereas the incantatory element of poetry ranges beyond, ready to interpenetrate, to hypnotize. Or perhaps precise and vivid images, an enclosed world, fed by metre, serve a sentiment that is indefinable, permeating, unspoken. Space is a homogeneous medium into which we are drawn and freely plunged by many representations of visual art: at the same time it is the mode of order and distinctiveness for separated objects.'

The combination of these two kinds of relationship with an object have special significance to the artist and to the æsthete. I refer on page 113 to Wordsworth, to his care for the singularity of primrose or peasant, for an enclosed constellation of feelings which, none the less, inspire in him sentiments of pantheism. (But the humanist artist alone has valued equally with the oceanic feeling, the sense of an object's actual particularity.) That instance is of subject-matter rather than of form: his devotion to Form influences, sometimes determines narrowly, the artist's preference in subject-matter. The distinction between them is not hard-and-fast but only convenient. I shall employ the term, Form (with capital), in order to indicate briefly those many sensuous aspects that distinguish art as the crown of other symbolic systems.

The reciprocity of parts, the 'inner working' that causes a painting, though viewed but formally, to be much more than the sum of those parts, is conveyed to us in terms primarily of our sense-perceptions, in terms of vision and touch. Such communication is so pleasurable that we may enjoy it, Clive Bell affirmed,

without conscious perception of the subject-matter. All the same, formal value does not exist apart from a particular subject or sentiment or function of the object, even in music and in ceramics: moreover the significance of the formal value issues from its own content, its own subject-matter, one so general as to be common to all art. I think that reciprocity, plasticity, rhythm, design, *etc.*, *etc.*, are employed to magnify a self-sufficient object (notably other than ourselves even though it expresses also a narcissistic self-glorification): at the same time they are employed to surround us with a far different kind of object, to suggest an entirety with which we can merge. (All pattern stems from some identity in difference.) And, whereas it is obvious that texture, or the reciprocity of parts, primarily suggests the self-sufficient object, whereas the flow of rhythm or a giant plasticity may easily draw us into the homogeneous beatitude of the oceanic feeling, I think it is impossible to tie a formal quality—the isolation is itself artificial—to one of these functions to the exclusion of the other: a pervasive theme embodies more than one unity: each formal quality has further function in the pulsation of the whole. A doubling of roles characterizes the masterpiece by which we experience the sensation of having the cake and yet of eating it without destruction, surfeit or waste-product. Form harmonizes this contradiction: it is the setting for the evocative ambiguities, for the associative collusion, of imagery: while serving culture and affirming outward things, it both provides and facilitates the echoing in all art of those urgent voices, deep in the mind, whose opposite, unmodulated, tones are nevertheless of one piece, whose character of condensation, when thus in company with distinctiveness, may contribute to the æsthetically deft or neat.

But though it be impossible to make a sure division, there is no difficulty in appreciating where the emphasis lies in any instance, or in a style, a period: indeed the history of art might be written in terms of an ever-changing fusion between the love

for the self-sufficient object, fully corporeal in essence, and the cultural disciplines for oceanic feeling.[1] Renaissance art, of course, is always characterized by the joyful recognition of self-sufficient objects ordered in space: yet in other books I have tried to show, with the help of terms not altogether dissimilar from those I now use, the difference, in the placing of these accents, between the architecture of Luciano Laurana and Brunellesco: on the one hand the emphasis upon objects, as if pre-existent, whose potentialities are uncovered in the guise of colour relationship, of surface texture and of the equal reciprocity of forms, to be valued for their inward glow like the distinct brother

[1] 'A portrait aims by definition at two essential and, in a sense, contradictory qualities: individuality and uniqueness; and totality or wholeness.' (E. Panofsky, *Early Netherlandish Art*, 1953.) Whereas this judgment might belong to any epoch of art criticism, it cannot be said of other passages in Panofsky's book that are close to my theme. For instance: 'From the sheer sensuous beauty of a genuine Jan Van Eyck there emanates a strange fascination not unlike that which we experience when permitting ourselves to be hypnotized by precious stones or when looking into deep water.' Panofsky finds this hypnotic or suffusing effect to be immanent not only in the Eyckian technique but especially in his use of the miniaturist's naturalistic diversity of detail. We are drawn into the painting, we are hypnotized by a style of slow verisimilitude that embraces all. The Eyckian form of transcendence contrasts coldly with the broad, less intimate, naturalism of Italy where classical styles uncover transcendence in terms of a humanist, robust, if more patently ideal, synthesis; or thus it appears to me, even though, as Panofsky says, 'The High Renaissance and the Baroque synthesis were to develop a technique so broad that the details appear to be submerged, first in wide areas of light and shade and later in the texture of impasto brushwork.' For, as he goes on to say, Jan Van Eyck evolved a technique so minute that the number of details comprised by the total form suggests infinity; and thereby, it seems to me (though not to Panofsky), often bestowed upon these details an infinite yet intimate loneliness or incompleteness that is almost hateful to the humanist.

This very brief reference to a contrast within European art of the Renaissance will serve perhaps to indicate that the kind of subtlety which I consider most pertinent, already flourishes in the work of some acknowledged masters in the history of art.

shapes which we discern in an evening light: on the other hand, movement, the suggestion of omnipotent flourish by means of a material that is itself no less subservient than clay, of an accent that cleaves us both from affinity and from separateness in order to recreate out of the material an all-inclusive stress with which we are one.

Here, and in the pages ahead, visible, tangible *objets d'art* provide the examples of æsthetic activity. Yet in poetry, for instance, image and metaphor similarly encompass mutual enhancement between sensuous units, culminating in a construction, in a Whole, that nevertheless refers beyond itself without breaking the entirety. This rounded æsthetic mode of treating subject-matter is employed upon a nexus of experience, of perception, thought and feeling, in the belief that the connections thus created are no less poignant than those which underlie this Form or mode itself. Poetic 'truth' is not, of course, truth, but it has its own precision, detachment and, above all, an immediacy that offers us a particular congruity joined with a wider sentiment; a pattern, in short, of experience in the terms of something sensuous or physical. The pattern, I submit, requires both for its creation and for its appreciation, the amalgam of attitudes to what is outside (and inside) us by which we merge with the world or contemplate what is other than ourselves. It is woven with the intertwined threads of these emotional relationships to objects: and thus, in the completed work, we view feeling as a full, sensuous, object containing a sensuous transcendent content: we are made aware once more of the primitive strength of the life-force in often harmonious union with the power of consciousness to define, to differentiate.

I apologize for these abstractions.

Art is symbol: the sprawling empire of symbolism radiates from the dream-world. From the angle of the symbolism of its subject-matter, art has often provided material for psycho-analytic study. But my governing theme is not of such kind. This

book attempts to substantiate, in the person of Michelangelo, the distinctive character of art as self-expression or catharsis, what is called the Form, the mode of treating each subject-matter. If Michelangelo's greatness is brought into nearer view, I shall not have entirely failed.

In discussing Michelangelo's relation with his father and brothers (Part I, Chapter 3), I have not referred to social and cultural values of the time. I am aware that even if the scholar of historical study cannot catch me treating as entirely personal to Michelangelo or to his family something which is better described in the terms of contemporary mœurs, he would still deprecate the abstraction and might invoke the incompleteness of our knowledge. Moreover, I select a small amount of evidence—it could be enlarged considerably without sharpening the point—from which wide conclusions are drawn. Having no belief in any novelist's inventions for behaviour and personality, I would fully share, for further reasons as well, the historian's distaste, were it not that I feel my summary of fact to be excused, and, in consequence, to be required, by a more massive appreciation of Michelangelo's art.

The achievement of an artist cannot be studied apart from the surrounding culture and the tradition in which he works. To-day more than ever, the scholarship of visual art is absorbed (at the expense of general appreciation or even of the comparisons such as I make with our own art) in fixing the derivations (if easily handled) for each plastic form and iconographic theme. An æsthetic effect contains a long line, perhaps many lines, of precise antecedents: this is a fact often neglected by those who come from other fields to the study of an artist: hence, it is no wonder that the manners of art scholarship have become more and more academic. On the other hand there is the worth (to us) whose interpretation, though it must be founded on this

scholarship, cannot be pursued entirely in terms so narrow, whether we are considering the masterpiece or themes in which a masterpiece is embedded. The widest theme of all, the nature of art, has little attention now from those who explore most closely its manifestations. Whereas there are powerful excuses for the neglect both of æsthetic speculation and of unusual sensibility, the study of art history, it is obvious, cannot be secluded in every case from a present understanding of human needs. I must therefore hope that this (by no means sporadic) attempt to discover certain fantasies that are common ground in the projection of Form, and then to relate how the genius of Michelangelo more than matched the great opportunities implicit in his tradition and in his time, may not be considered by scholars *ipso facto* as offensive.

Michelangelo has been fortunate in many of his students: all lovers of art are indebted to unimpassioned investigators of so fervid a field of human experience. I trespass at times on this well surveyed ground which, as I hope, from other places of the book persists in the middle distance. In regard to Michelangelo's poems which are so much less well known, my locus is rather different.

2

SYNOPSIS OF MICHELANGELO'S LIFE AND KNOWN WORKS (OTHER THAN DRAWINGS AND POEMS)

Not all statements (nor omissions) even in so bald an outline are of equal validity: qualifications and references would be inappropriate in an *aide-mémoire*.

Michelagniolo di Ludovico Buonarroti Simoni was born on March 6th, 1475: he died under three weeks before attaining eighty-nine years, on February 18th, 1564.

He was born at Caprese, above the Valle della Singerna, a Florentine dependency where his father held the appointment of *podestà* or governor; the term of office finished less than a month afterwards. It is said that Michelangelo was put out to nurse with a woman at Settignano, above Florence, where the family owned a farm. His mother died when he was six. At ten he joined the Grammar School of a certain Francesco da Urbino. Granacci, six

years older than Michelangelo, for long afterwards a friend, took him to the *bottega* or studio of Domenico Ghirlandaio where he worked. At the age of thirteen, Michelangelo joined the *bottega*, as pupil and helper (1488). The usual age for apprenticeship was ten: on the other hand the contract showed that Michelangelo would be paid a small wage. Probably at this time he made the extant drawings after Giotto and Masaccio. The contract was for three years: Michelangelo left, probably after a year, to study the collections of Lorenzo de' Medici, the Magnificent, in whose palace he was taken to live. Michelangelo executed a head of a Faun in antique style (lost). The sculptor Bertoldo was in charge of the collections. Lorenzo died in 1492.

This is thought to be the period of two marble reliefs by Michelangelo, the first in low relief, the second in high, the so-called Virgin of the Stairs and the Battle of the Centaurs (Casa Buonarroti, Florence).

Lorenzo was succeeded by his son, Piero. Michelangelo carved a Hercules (more than life-size) which was sold in 1529 to the French king, Francis I. It has been lost since 1713 with the abandonment of the garden at Fontainebleau in which it stood. At this time also he carved a wooden crucifix (lost) for the Prior of Santo Spirito who gave him permission to dissect corpses.

In 1494, observing the unpopularity of Piero (who was soon to be driven away), and doubtless believing a rumour that the French king might plunder the city, Michelangelo left Florence for Venice and Bologna. He lived over a year in Bologna at the house of a nobleman, Gian Francesco Aldovrandi. He was given the job of completing the tomb of St. Dominic in the church of that name by carving two statuettes for the sarcophagus lid and one to stand near the shrine. He returned in 1495 to Florence where a new government, without the ruling Medici, had been formed under the influence of Savonarola. Another branch of the Medici family, however, were in some favour: Lorenzo di Pier Francesco de' Medici commissioned the carving of a boy St. John

the Baptist, now lost. Michelangelo carved also a small sleeping Cupid which later passed into the Gonzaga collection at Mantua (lost since the collection was sold to Charles I of England in 1628).

The Cupid had first been sold to a dealer from Rome: the artist went there himself in June, 1496, to seek his fortune (which was unlikely to prosper in Savonarola's Florence). Cardinal Riario, who was living in the new Cancelleria palace, bought a marble block for Michelangelo. Probably this block was used for the Bacchus (Bargello, Florence) which Jacopo Galli bought, as well as buying a life-size Apollo or Cupid (lost). Galli served as intermediary of the contract for the marble Pietà of St. Peter's (first chapel on the right). The other work of which there is mention in the first Roman period, was a cartoon (lost) for the Stigmatization of St. Francis.

In the spring of 1501 Michelangelo returned to Florence until his second departure for Rome in the spring of 1505. He executed the marble David between August, 1501, and March, 1504 (Accademia, Florence), for the Opera del Duomo; he undertook to sculpt the twelve Apostles for the Cathedral, commissioned by the Arte della Lana. Of these, only the St. Matthew (Accademia) was started, probably in 1506. He had a commission also for fifteen statuettes to decorate the Piccolomini chapel in the Cathedral at Siena. Four only were delivered, perhaps partly finished by assistants. It is likely that the Bruges Madonna and Child (Notre-Dame) belongs principally to this period, three circular pieces also, or tondi, two in marble relief, the Madonna Pitti of the Bargello, the Madonna Taddei of the Royal Academy, London, and a tempera painting, the Doni Holy Family in the Uffizi, Florence. A bronze David, destined for a French marshal, was sent eventually to the king's treasurer, after being finished by B. da Rovezzano (lost). Together with the marble David, the most celebrated work of these extraordinarily fertile four years was the cartoon of the Battle of Cascina or the Bathers, a composition

of more than life-size nudes for the proposed fresco in the Sala del Consiglio, Palazzo Vecchio. About 1516, this renowned design was divided into many pieces, probably by the students who used to copy it. Some parts were sold, all were eventually lost. A grisaille at Holkham is the only surviving version that is plausible. The artist experienced an even more rapid destruction of his work in the over life-size bronze seated statue of Pope Julius II on which he had worked for more than a year, during his second visit to Bologna, whereas the Cascina cartoon had occupied him for a few months only. The bronze statue was destroyed upon the restoration of the Bentivoglio family to Bologna, less than four years after completion.

In the spring of 1505, Michelangelo was called to Rome by Pope Julius II in order that he might execute his (Julius') tomb in the new choir of the old St. Peter's. Michelangelo then spent eight months in Carrara for the marble. The Pope seems to have lost interest in the tomb by the spring of 1506: he had decided to reconstruct the whole of St. Peter's, using Bramante's plans. Rebuffed in demands for expense money, Michelangelo left Rome secretly for Florence the day before the ceremonial laying of the first stone. The Pope ordered the return of Michelangelo who replied that he could continue the tomb very well, indeed better, in Florence. After the Pope had sent a *breve*, after Michelangelo had received assurance of safety, at the end of 1506 he submitted to the summons to Bologna which Julius meanwhile had reconquered, appearing before the Pope, he wrote later, with a rope round his neck. Then followed the commission for the bronze seated figure mentioned above.

He returned to Florence in the spring of 1508: within a few weeks he was ordered to Rome by Julius to paint the vault and the higher parts of the side walls in the Sistine chapel. He executed this work in the subsequent four and a half years with the help of a few garzoni. Prophets, sibyls, nudes and scenes from Genesis are represented upon the vault; there is the figuration of

other parts of the Old Testament for lunettes and spandrels, including the ancestors of Christ. The technique is fresco: when engaged on the ceiling, he worked on the scaffolding looking up and painting above his head, some 55 to 60 feet from the chapel floor. The length of the ceiling is 40.23 metres, the breadth about 13½ metres. His previous experience of fresco painting is likely to have been small. The work was finished at the end of October, 1512. It is probable that near this time Michelangelo made a cartoon of the *Pietà* which was used by Sebastiano del Piombo for his famous painting at Viterbo.

Julius died in February, 1513: his heirs made a new contract for the suspended tomb. The original plan of 1505 had been for a free-standing shrine with more than forty large statues and reliefs. The contract of 1513 was for a wall monument, though of an even more ambitious scale. The contract of 1516 shows a modified version. Julius' heirs were particularly restive in 1522; Michelangelo thought of selling the executed work and of giving them the proceeds in repayment of the advances that had been made to him. In 1525 he suggested a further modified plan which the heirs indignantly rejected: but the fourth contract of 1532 shows a modest plan; the site is now at San Pietro in Vincoli. (No doubt to humour the heir, the Duke of Urbino, Michelangelo made him a design for a silver salt-cellar and a little bronze horse in 1537 (lost).) It is possible that the Victor statue in the Palazzo Vecchio, Florence, was intended for the plan of 1532, though it is likely to have been carved some years earlier, together with the unfinished Giants or Slaves of the Accademia, Florence. The negotiations behind the contracts were partly triangular since it was Michelangelo's commitments with the Medici that prevented him from completing the tomb. Not that Michelangelo considered himself safe—Julius' dangerous anger was attributed also to his heirs—or excused in the matter, and he felt it necessary to make constant representations and rebuttals. The final contract belongs to 1542: largely the

work of assistants, the monument we see to-day in San Pietro in Vincoli, was erected by the spring of 1545. As well as the Moses (moved forward and slightly raised in 1816), some of the stones of the 1505 and 1513 plans figure in the base. Michelangelo carved the Leah, already well advanced, and Rachel for this monument in 1542 and after. In the Casa Buonarroti, the British and Victoria and Albert Museums, there are eight small models, disputed in varying degrees, which are thought to be connected with figures for the Julian tomb.

To go back. After the death of Julius, Michelangelo was working in Rome between 1513 and 1516 on the contract of 1513: the Moses and the Slaves of the Louvre belong principally to this time. He had a studio at the Macello de' Corvi in Trajan's Forum, his property in Rome for over fifty years until his death.

In 1517 Michelangelo made models for the façade (with plentiful room for statuary) of San Lorenzo in Florence, at the behest of Pope Leo X. This project was no less prodigal than the Julius tomb and even less repaying, the cause of three wasted years, as he himself termed them, spent largely among the quarries and on the roads of Carrara and Seravezza. In 1520 the San Lorenzo façade contract of 1518 was suspended, probably owing to the huge expense. San Lorenzo was never to have a façade. In 1519 Michelangelo suggested that he should make a tomb in Florence for Dante's remains. In this year he began the marble Risen Christ, completed by two assistants, of S.M. sopra Minerva, Rome. An earlier version had been abandoned because of a black vein in the marble (lost).

From 1520–1, from 1523–7 and again from 1530–4, Michelangelo was working in Florence on the Medici funeral chapel at San Lorenzo and upon the Laurentian library adjoining the church. (Also the tribune for the relics, over the main door.) The chapel frames the marble tombs of two Medici Dukes, Captains of the Church, below whose seated figures are their sarcophagi with back-to-back reclining figures of the Times of

the Day upon the lids. In the recess of the chapel's entrance wall, opposite the altar, there is a carved Madonna and Child (the Medici Madonna) with two patron saints (the latter by assistants), figures executed for a double tomb originally designed for the same site. Tombs for the two Medici Popes, Leo X and Clement VII, were planned either for the church or the chapel precincts. Further statuary (vide the fragmentary model of a river god in the Accademia, and the Leningrad marble boy), as well as painting, were planned but not completed, except for a part of the cupola painted with decorations by Giovanni da Udine (whitewashed over).

Returned to Florence since 1512, the Medici party was again driven out at the time of the sack of Rome (May, 1527): the republic was revived. While threatened by Pope and Emperor, the city put Michelangelo in charge of the fortifications and also of the block for a Hercules and Cacus or Samson and Philistine. (Possible clay model—it may well have been for the Julian tomb—in Casa Buonarroti. This project is not to be confused with another, near in time, for a Samson with two Philistines, of which there are several copies.) In July, 1529, Michelangelo went to Ferrara to study the fortifications. With Alfonso D'Este in mind, who wanted a work from him, he painted the Leda (lost), of which there are copies. But first, in September, 1529, fearing Florence would be betrayed, Michelangelo fled to Venice. He returned to Florence in November after the promise of a safe-conduct. The city surrendered in August, 1530. After a short time of hiding, Michelangelo had to make himself pleasant to the Pope's delegate, Baccio Valori, for whom he carved the Apollo-David (Bargello). He drew a cartoon of the Noli mi tangere (lost) for the commander of the Imperial Army. He drew in 1532 or 1533 a cartoon for a Venus and Cupid. (The dilapidated cartoon in the Naples Museum is possibly the original.) Michelangelo made designs for fellow-artists, especially for Sebastiano del

Piombo, and later for Marcello Venusti and Daniele da Volterra: scholars have associated many Michelangelo drawings with lost designs.

In 1534, at the age of fifty-nine, he left Florence finally for Rome where, as far as we know, except for a short visit to Spoleto at the time of a Spanish threat to the city (1556), he spent the remaining thirty years of his life. He was painting the Last Judgment, covering the whole wall above the altar of the Sistine chapel, from 1536–41. The Brutus bust (Bargello) probably belongs to this period, near the beginning of which he made friends with the exalted religious lady (of a circle and doctrine not untouched by the Reformation), Vittoria Colonna, the middle-aged widow of the Marquis of Pescara, who continued until her death in 1547, and after, to be of great importance to him. He made several drawings for her. At this time he was writing many poems: some of them are addressed to Vittoria Colonna, others to a young Roman nobleman, Tommaso de'Cavalieri, whom he had met in 1532.

From 1542–50 Michelangelo was painting the twin frescoes (each 6.25 × 6.61 metres) of the Paoline Chapel in the Vatican. The *Epifania* cartoon of the British Museum is contemporaneous with the second of these frescoes.

Thereafter he devoted himself principally to architecture. Appointed in 1547, he remained until his death architect-in-chief of St. Peter's: in the previous year he had taken on the completion of the Farnese palace and he had made the plans for the Capitol: he had also worked in the Vatican. In 1551 he presented the model to Pope Julius III for a palace.

The *Pietà* of the Duomo in Florence was carved between 1545 and 1555. (The artist mutilated it: Tiberio Calcagni restored and continued the work.) It is likely that the Rondanini *Pietà* was begun in 1555. The Porta Pia, the plans for the church of the Florentines in Rome (not executed), for the transformation of the Baths of Diocletian into the church and convent of S.M. degli

Angeli, the plans for the capella Sforza in S.M. Maggiore, are the last architectural works of which we know.

Upon his death in 1564, Michelangelo's body was brought to Florence. A very elaborate funeral, decorated by the work of Florentine artists, took place at San Lorenzo in July. He was buried at Santa Croce in the parish where his family had long lived, and would continue to live until the middle of the last century.

Michelangelo was the second of five brothers. The elder brother, Lionardo (b. 1473), who is said to have been always delicate, became a Dominican monk. Defrocked, he fled from Viterbo to Michelangelo (in Rome) who gave the assistance for his return to Florence (1497). There is a mention of Lionardo as a monk in 1510: otherwise we know nothing of him, except that Michelangelo's grand-nephew said that the flight from Viterbo was due to Lionardo's partisanship for Savonarola who had recently been excommunicated. In adult life, and probably long before, Lionardo's monasticism gave over to Michelangelo the role of elder brother that suited him. It is remarkable that among the hundreds of extant letters of this close family there is no other mention of brother Lionardo, who probably died in Pisa soon after 1510.

Buonarroto, the first younger brother (1477–1528), worked in a banking firm, then in the woolshop of Lorenzo Strozzi, later with Giovan Simone (see below) as co-owner of a woolshop for which Michelangelo put up the money. Buonarroto held several public offices.

The next brother was Giovan Simone (1479–1548): he is said to have written some poetry.

The youngest brother was Gismondo (1481–1555). Family tradition has it that he was a soldier. Later, at any rate, he was working on the land, in no better circumstance (except for Michelangelo's help) than a peasant.

There is one mention of 'brother Matteo'. If this reference is indeed to a sibling, then it is likely that Matteo was a son of Ludovico's, the father's, second marriage in 1485.

ABBREVIATED REFERENCES IN THE TEXT

F. = Carl Frey. *Die Dichtungen des Michelagniolo Buonarroti*. Berlin, 1897.

F. Briefe = Karl Frey, *Sammlung Ausgewählter Briefe an Michelagniolo Buonarroti*. Berlin, 1899.

M. = Gaetano Milanesi. *Le Lettere di Michelangelo Buonarroti coi Ricordi ed i Contratti Artistici*. Florence, 1875.

Tolnay = Charles de Tolnay. *Michelangelo*. 4 vols. Princeton University Press, 1943–54.

Wilde = Johannes Wilde. *Italian Drawings in the Department of Prints and Drawings in the British Museum. Michelangelo and his Studio*. London, 1953.

3

MICHELANGELO AND HIS FAMILY

Except for the name, marriage and death, nothing is known about Michelangelo's mother, who died when he was six (1481). As well as Vasari (1568), Condivi, Michelangelo's pupil, who published a short biography in the master's lifetime (1553), reports that Michelangelo was put out to nurse at Settignano with a woman who was the wife and daughter of stonecutters. Hence, these authors assert, Michelangelo used to remark that it was no wonder he became a sculptor. Condivi adds that possibly he was joking, or possibly he knew that a nurse's milk might well introduce a new propensity.[1]

It is important to understand that it was a new propensity from which Michelangelo was not unwilling at times in his old age to dissociate himself on other than religious grounds; new, in the sense that it was foreign to the pretensions of his family. The extant letters to his father and brothers do not mention any æsthetic value of his work, whereas they often refer to the hardness of his situation and to the money he earns. These aspects

alone, of course, held the interest of his correspondents; they are anxious for him, and he is the family's chief breadwinner. Michelangelo wants his father's prayers as when he describes to Buonarroto, one of his younger brothers, the anxiety and difficulty about the casting of the Julius statue in Bologna, and the Pope's satisfaction with the model. (The father had asked to be informed when he should say prayers for the casting. (M. pp. 71–73 and 76.) All such arduous work is undertaken solely in order to help the family, he likes to tell them (M. pp. 47 and 150: 'solo per aiutar la casa mia'). 'See that you keep alive', he writes to his father in 1512 at the time the Medici were returned to Florence and the father was fined. 'And if you can't obtain the earthly honours of other citizens, it's enough that you have bread and live well with Christ and in poverty as I do here.' Formerly the family had been a good deal richer: except for sometimes obtaining a small authority in government posts, the father would seem to have had no profession.

When Michelangelo was seventy-three, he wrote to his young nephew asking him to tell a priest not to address letters to Michelangelo, Sculptor, because he is not known except as Michelangelo Buonarroti[2]; and if a Florentine citizen wanted someone to paint an altar-piece, he must find a painter; as for himself, he was never painter nor sculptor in the manner of keeping a shop. 'I have always looked to my dignity and the honour of my father and brothers. I have served three Popes but that was under compulsion.' (M. p. 225.)

I do not think it would be enlightening to say that Michelangelo was a snob. On the contrary, in view of the poor social status of the artist—a mere artisan—which he did much to alter, the fact that Michelangelo was determined to strengthen through art the pride and wealth of his family, is a measure of his huge belief in the reparative nature of æsthetic activity. He cared nothing for appearances[3]: though he became rich, he chose to live very simply in some degree of squalor: he preferred

to be lonely. He continued to accumulate money for the family long after his father and two of his four brothers were dead. Though this 'saving' of the family was conceived in terms of restoring their position, it is obvious that the compulsiveness at work did not issue in the predominant need for social approbation. He paraded himself in letters and poems as the most miserable of men; he was also not slow to think and say that each of the close relatives was worthless. He felt persecuted by them. (The father on one occasion at least made use of Michelangelo's money without consulting him, but he was quick to share with Michelangelo the consequent anger, regret and alarm. (F. Briefe, pp. 16–19.) In regard to his unreliable and impulsive family, Michelangelo showed bitterness that is the measure, not so much of thwarted self-approbation, as of enslavement.

It cannot be said in the light of their letters that the family were not affectionate, though they were 'on the make', careless in the use of money furnished by Michelangelo, ready to ask a favour from him. All shared in the anxiety concerning each other's safety and health. Both the father and Buonaroto urge Michelangelo at different times to throw up his work and return to them: it would seem they were unable to make an important decision without his help. Even in offering advice, they are usually careful to stress that he, Michelangelo, is the wise one. Although narrow and idiosyncratic, the father is capable of showing humility, not in the face of his son's genius but of his prudence and business sense, even at the age of seventy-seven in connection with a matter (the value of a farm) about which he, the father, probably with time on his hands, may well have been better informed[4] (F. Briefe, p. 175). We prefer the father, Ludovico, on the evidence of the letters to the favourite brother, Buonarroto, who died of the plague in 1528, it is said, in Michelangelo's arms.[5] Also Buonarroto, in spite of his two marriages, depended upon Michelangelo's judgment, eagerly

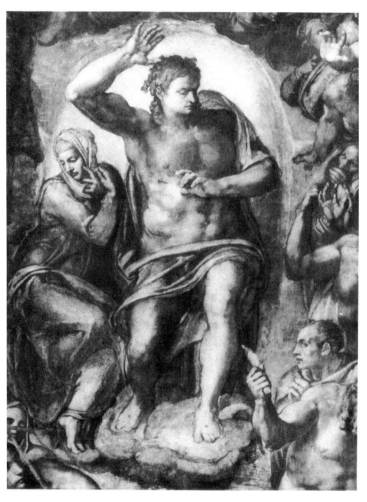

1. The Redeemer and Virgin Mary of the Last Judgment. Fresco

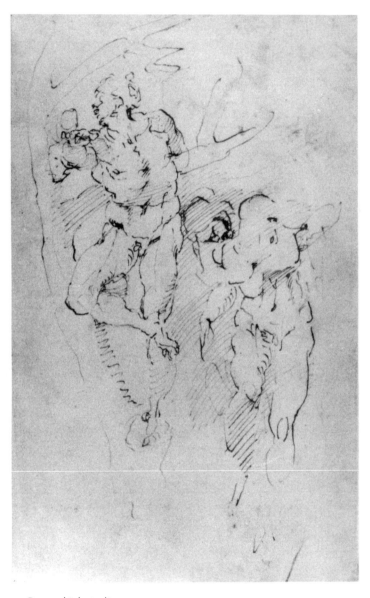

2. Pen and ink studies

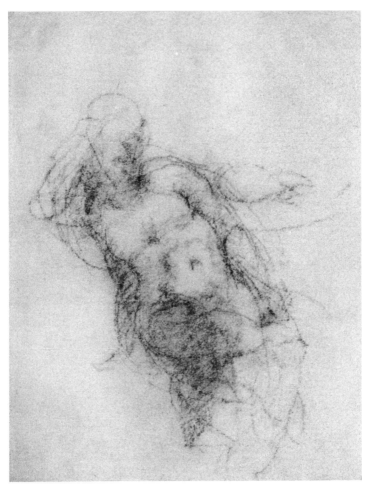

3. Rapid sketch in black chalk

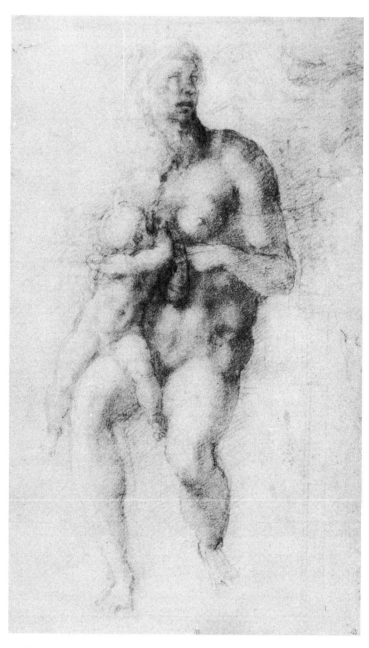

4. The Holy Family with the infant St. John. Black chalk

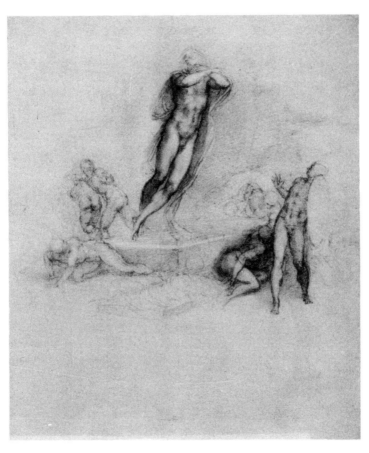

5. The Resurrrection of Christ. Black chalk

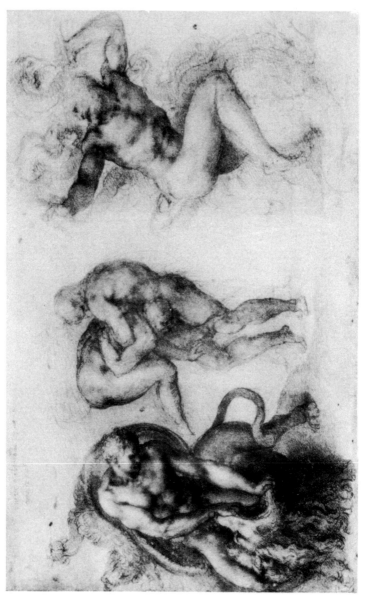

6. The Three Labours of Hercules. Red chalk

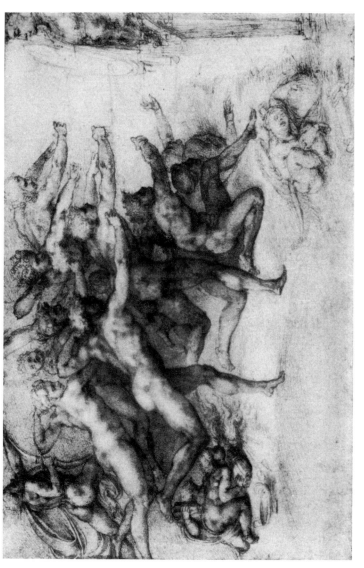

7. Archers Shooting at a Herm. Red chalk

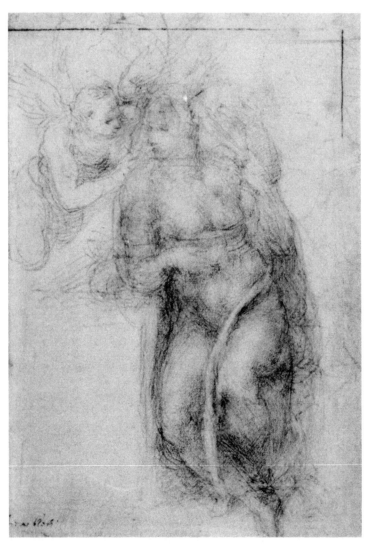

8. The Annunciation. Black chalk

fulfilled his commissions, identifying himself as closely with the Buonarroti interests.

The morose and tortured Michelangelo mothered and, indeed, fathered this motherless, sisterless, narrow family. Ludovico, the father, married again, but women seem to have played little open part in the family stresses.[6]

The first point I want to emphasize in the matter of his family, is Michelangelo's prudence, his grip upon reality in spite of a great excess of temperament. Unlike pure visionaries, artists need, whatever the size of their wings, a good stance for the ground. They seek to dissipate the depression that encloses them, to restore, to revive; better than most, they have recognized the constancy of death.

Michelangelo was, of course, enslaved by his art in which he has restored the whole world. It happens that he was likewise enslaved by the family circle, however short the time he could give to them, however much with another part of his mind he resented the weight they put on him. Testimony comes in a letter to Buonarroto, probably of 1513. The letter's complaint is first of Buonarroto's extravagance. Michelangelo wants to know if he is keeping an account and he recalls an occasion when Buonarroto was in Rome and he had boasted of spending large sums of his own money: Michelangelo had not unmasked him nor, indeed, was he surprised, because he knew his brother only too well. 'If you have enough mind to be able to contemplate the truth, you would not have said: "I spent so and so of my own money", nor would you have come here to press me over your affairs after all that I have done in the past: you would have said instead: "Michelangelo knows what he has written to us, and if he can't do something to help at once, there must be some difficulty for him about which we know nothing: and we must be patient because it is useless to spur a horse who is running with all his might and more". But you don't know me and have never known me.' (M. p. 109.)

Nor have his biographers known him in this respect. It is usual to stress his generosity to worthless relations as well as his many other gifts, particularly to the poor. They overlook the manifest compulsiveness; they overlook the horse who is running with all his might, spurred invisibly by guilt, anxiety, the desire to restore, as well as by love. He had larger things with which constantly to occupy his mind; no one will have known it more clearly than himself. But the wide sublimation through art could not disengage him from the narrower field of undue apprehensiveness. It is never easy, in fact, it is finally impossible, to separate altogether love and affection from anxiety; yet we often recognize at once a strong degree of anxious superfluity.

Probably over a third of the extant letters, published and unpublished, that Michelangelo wrote to his father and brothers, must be dated between 1508 and 1512 when he was painting the Sistine chapel. There appears to have been a lull in the work between September 1510, after a section had been finished (Pope Julius was lately departed for Bologna) and January 1511 (Tolnay, Vol. II, p. 111). On September 5th and again on the 7th, Michelangelo was awaiting payment for what he had recently completed and an advance for the rest. He says he is moneyless since the Pope has left without having settled. Buonarroto is ill; Ludovico must provide for Buonarroto by drawing on Michelangelo's savings in Florence. And should Buonarroto be in danger, he himself would come at once, even though he would have to risk losing the money which, he thinks, should already have been paid over. 'Men are worth more than money', he concludes. (M. pp. 30 and 31.)

But the enslavement exceeded the demands of such love and undoubted generosity of mind. The relatives were not forbearing: they inflicted themselves upon the distracted artist. All three younger brothers, doubtless impelled by the appealing Italian compound of curiosity, family solidarity and self-interest, turned up in Rome to further their prospects in the early anxious

years of the Sistine undertaking. Michelangelo writes to Buonarroto in October 1509: 'It seems to me you don't understand how I am situated here. . . . I shall do what I can. It seems that Gismondo is coming to expedite his business. Tell him not to take me into his calculations, not because I don't love him as a brother but because I can't help him in any way. I am taken up with loving myself more than others and I can't provide myself with the necessaries of life. I am in need, worn out and without friends, nor do I want any: nor have I the time to eat as much as I should; so don't let me have more troubles because I can't stand another ounce.' (M. p. 97.)

It is surely not strange that the prickly, unsociable Michelangelo in whom there was overwhelming anger[7] as well as his generosity or his fear, who was notorious for deep melancholy, should have become the cushion to mitigate the hard life of others. Nor is it strange that we find in the massive, omnipotent proportions of many of his figures, a full measure of passive and patient receptivity.

There exists, of course, the other side, the resentment, the explosiveness, the contempt. More than a third of all the surviving letters are addressed to Michelangelo's young nephew, Lionardo, the son of Buonarroto: they were written between 1540 and December 1563, two months before Michelangelo died. He was attached to the nephew, not perhaps for himself but as the inheritor of the family. Yet on the whole, the letters reflect a profound irritation. Lionardo becomes 'them', that is to say, Michelangelo's father and brothers (mostly dead) who never asked him to spend money on himself. Thus, the old man writes to the nephew: 'About your rushing to Rome in such haste, I don't know whether you would have come so far if I were in the utmost poverty and lacking bread. It's enough to throw money about that you haven't earned. What a fear you have of losing the inheritance. . . . Yours is the love of a wood-worm. If you really loved me, you would have written: "Michelangelo, spend the

three thousand scudi on yourself: you have given us much and it's enough: we care more for your life than for your property." '

'You all have lived off me now for forty years', he adds in writing to this young man of twenty-six, 'and I haven't had even a good word from any of you in return.' (M. p. 187.) Two years earlier he had written to the unfortunate Lionardo who had come to Rome because of Michelangelo's severe illness: 'Don't my possessions in Florence suffice? You can't deny you are just like your father (Buonarroto) who drove me out of my house in Florence.'⁸ (M. p. 174.) Lionardo, in spite of Michelangelo's innuendoes, does not strike us as an unusually calculating young man. He appended as was his custom the date on which he received this unaddressed letter. Doubtless he was in Rome but was not allowed to make the visit which had been the object of his journey, undertaken, it is likely, at the instance of Michelangelo's friends.

This letter, in which the uncle tells the nephew not to appear before him, not to write to him any more, calls to mind a letter Michelangelo wrote to his father twenty-one years before (M. p. 55). Instead of *Reverendissimo* or *Carissimo Padre*, the missive opens with the one word, *Ludovico*. After arguing in a patient tone about a business matter concerning which he says he entirely fails to understand what else the (muddle-headed and accusing) father could want in the affair, Michelangelo goes on: 'If it is that you find my very existence tiresome, you have hit on a way to satisfy yourself and to return that key to a treasure which you say I command: and you will do well: after all, everyone in Florence knows what a rich man you are, how that I have always robbed you and deserve punishment: you will be applauded. So, tell everyone just what you please about me, but don't write to me any more because you stop me working.'

But it must be considered doubtful, even here, whether the bitter tone has precedence over the desire to calm the father's accusing fancies, to make amend even with ridicule. There is an

extraordinary letter (M. p. 49) wherein a sardonic but desperate humility accompanies the expression of his own very strong feelings of persecution. 'Dearest father, I was astonished by the news of you the other day when I didn't find you at home: and now that I gather you are upset with me and say I have turned you out, I wonder the more. For I am certain that from the day I was born until now I have always had the intention both in big things and small to please you, and always the labours I have undergone were out of love for you. . . . It amazes me that you so quickly forget all this, you with your sons who have had me on trial for more than thirty years. And, of course, you know well that I have always schemed and done the best for you whenever opportunity occurred. How then can you go about saying I drove you away? Don't you see what harm you are doing me? Together with the other miseries I endure for other reasons, this completes my bitterness, and all this misery is the fruit of my love for you. You certainly repay me well! But let it be as you say. I want to persuade myself that what I have always done is shameful and harmful: and so, as if I had done it, I ask your forgiveness. Try to forgive your son who has always lived badly and done all the evils that are possible in this world. Once again, I ask you to forgive me, the wretch that I am, and spare me the harm of your spreading the story that I drove you out. It hurts me more than you think. I am, you see, your son.'

The fear of losing each other, we have said, is the dominant emotional theme in the family letters. 'Men are worth more than money.' In the face of political dangers, Michelangelo writes, 'Be the first to flee' (M. p. 107). 'Think only of keeping alive' (and not about wealth), he urges his father. 'I wouldn't exchange your life for all the gold in the world.'[9] (M. p. 32.) Anxiously he tries to counteract with religious exhortation and common sense the father's patent persecutory fears whose opposite face sometimes seems to be a certain inconsequence. When the father is ill, though out of immediate danger, Michelangelo implores

Buonarroto (who has already shown the utmost concern in telling Michelangelo) to make provision and to employ his wife in aid of Ludovico. He, Michelangelo, will make it up to all of them: the fount of all his effort had always been for the help of his father before he should die. (M. p. 132.) (It would seem he could never entirely convince himself that he has been successful: perhaps Buonarroto's wife could do better.[10]) He is very anxious—as he showed himself again over the deaths of his brothers—that if, by chance, there should be a relapse, his father would not lose the advantage of the last sacraments to promote his celestial living. 'I have always schemed to revive our family', he wrote much later to his nephew, 'but I did not have brothers whom it was possible to raise up.' (M. p. 197.) The bitterness, I think, was more sorrowful than the usual feeling of failure to satisfy family pride. There had been insufficient proof for his own satisfaction that his father and brothers had exploited him successfully. He hated to be exploited and he knew them to be worthless: in any case, his feeling of persecution was very strong: even so, he preferred to make every anxious sacrifice in order to simulate an eternity for his family's motherless life, to secure their slipping existence. Nothing would be enough, nothing could convince him he had done enough, so profound was the melancholy guilt that centred on them, particularly on the father.

In the lines (F. p. 47) commemorating the death of his father as well as the death of Buonarroto some years before, he addresses his father saying that he will speak of his dead son first. To him the poet was drawn by love, to the father by duty. 'My brother is painted on my memory but you, father, are sculpted alive in the middle of my heart.' I take this wording literally: the very father, primitive as the stone, dwelt within him, a person to be instructed, still more to be placated, a persecuting as well as a persecuted figure, evoking nevertheless a certain pleasurable passivity in a host who may often have desired to usurp the

mother's place.[11] Ludovico is so immediately settled in heaven by the poet that some commentators have divined that Michelangelo is voicing heresy, that is to say, the denial of purgatory. 'In heaven', he concludes, 'the holy love of father and son will grow. . . . ' Thereafter he turned even more to religion, to a father embroiled not only with images of God but with those of the Saviour towards whom the last poems attest a deepening passive attitude. On the other hand, the death of his father seems to have released the full hatred of tyrants in his native land to which he never returned.[12]

It is part of my view that I assume the pressure (upon us all) of some such once-corporeal object which Michelangelo carried about with him, a figure he wooed, pacified, imitated,[13] nursed, even while the host performed similar conjuring tricks far more widely with the materials of the actual world, primarily on behalf of a maternal object through the sublimation, art. The broader restorative aim never ousted the narrower: the striking feature is their combination. A strong passive, as well as controlling and restorative, attitude towards the narrower and nearer image was incorporated into the tensions of his art, whence there flowers an all-inclusive tortured mastery characteristic of his figures and of his own ideal self, his own self-mastery. Yet even the wrapt, furcate agent, God the Father of the Adam 'history', possesses a form and a position in regard to the lower half of his body which would not be inappropriate to a reclining Venus (plate 10). The bisexual congregation of the Sistine vault proposes a tremendous and overpowering strength: hence the *terribilità*.[14]

It is likely, apart from Condivi's assertion of beatings, that Ludovico had opposed Michelangelo's desire to be an artist; and that consent was forthcoming in the face not only of persistence but of an unique skill which seemed to promise gold. At the age of twenty-two, he is signing letters, *Michelagniolo, scultore in Roma*. The signature becomes notable eleven years later when he is

painting the Sistine vault. Near the beginning of the task, he said that painting was not his profession (M. p. 17). Even after a large part of the ceiling had been finished with success, he pointed out in a burlesque poem (F. p. 7) that he was no painter. Yet the frescoes of the Sistine vault are generally recognized to be the most colossal feat known to pictorial art.

Michelangelo's humility rings no less truly than his pride. Except in the case of the first plan for the Julian tomb, of plans for the façade of San Lorenzo and for the Church of the Florentines in Rome—he was anxious that they should be executed—we do not know of any expression of real satisfaction in what he performed. Vasari stresses more than once Michelangelo's modesty as an artist. 'Michelangelo having been wont to say that if he had to satisfy himself in what he did, he would have sent out few, nay, not even one (sculpture).' Though masterful, he was subservient especially to the father within (in reality, it seems, an impetuous yet sometimes humble man). There was nothing forward-looking nor expansive in these attitudes. On the contrary, he was led to demand some hypothetical, changeless condition of the once noble family, Buonarroti Simoni, in harmony with the conservative tendencies of his own deep melancholy: that melancholy served as a barrier to the corresponding elation, provided a certain detachment from unparalleled reparative feats in art, a certain pessimism that did not disallow the slow counterpart of omnipotent undertakings, the Julian tomb, the Sistine vault, the façade of San Lorenzo, the rebuilding of St. Peter's, not to mention the taming of marble mountains.[15]

As long as it survives, the great work of art is the sole undiminished creation. Such an artist cannot easily tolerate his god-like stature. Many have failed when most was lying in their grasp, drowned by an ocean of illimitable achievement. Hubris for Michelangelo, whose success is perhaps the most individual and obvious of all, was not in question. Little as he valued his near-equals in art, he remained to himself the most wretched of men.[16]

I have wanted to make this point. Another reason for expatiating upon the Buonarroti is for their connection with Michelangelo's patrons who will, of course, have tended to elicit from him some of the responses that had crystallized in the family circle. But if we now pass from Ludovico to Pope Julius, there is no need to examine Michelangelo's exchanges with this or with other potentates in order to assert that such powerful fathers could have been an important influence on his art: in short, that not only æsthetic sublimations irrespective of their context but the intrusion also of the mighty patron helped to enlarge to heroic size a homely anger, for instance, which may have once figured more directly during a family quarrel over a credit or the ownership of a farm. In the Flood scene on the Sistine vault we witness the chronic crises of brotherhood under the ægis of an old man. But the marble Moses with the huge knee, with horns, disposer of the fertilizing rivulets of cascading beard, has achieved a mastery (Freud) over the very tensions that have rocketed him into a superhuman sphere. Even though he is dejected, self-mastery, the prime proof for Michelangelo of magnitude, impregnates the shambling bearded figure, for example, with his arms akimbo on an elongated torso, in the bottom right-hand corner of the Crucifixion of St. Peter (capella Paolina, Vatican (Plate 22)).

Julius II, commissioner of the tomb and of the Sistine decoration, was Michelangelo's first Pope. Among recent writers, Frederick Hartt has stressed the importance to his work of Julius' personality. An opponent of the Borgias—Julius, four years after his accession, refused to remain in the Borgia apartments—he was, according to this view, the purveyor of a 'heroic and seminal' Christianity in which the Body of Christ, the phallic Rovere oak or acorn (Rovere was the family name) and the Tree of Life symbolism, were incorporated with Michelangelo's help into a personal mythology.[17]

At any rate, there is no need to doubt that the thunderous role

that Julius, already an old man, adopted with extraordinary ardour and energy upon his accession, fired Michelangelo's imagination, his terror no less than intransigence. In Julius' service he invented omnipotent forms that bestow an ideal activity upon what is corporeal, an ideal receptivity also, whereby ceaseless tension is married to an unbounded health unknown in the North.

It is not necessary for my purpose to relate the story of the Julian tomb, the chief external tragedy of Michelangelo's life: it dragged on for nearly forty years (with a little coda eight years after). An inspiration in the first place, the tomb became a stimulant of persecutory fears and of guilt. At the same time, he could not, under pressure, resist a novel undertaking if it were colossal enough. He feared to lose touch with a new persuasive patron of real power[18]: there accompanied the anxiety an attraction to the patron's profligacy which, while it inspired him, often wasted much of his time, as when he spent three years on the San Lorenzo façade among the quarries of Carrara and Seravezza. Until Michelangelo's interest was fully aroused, the patron had to go to some trouble with promises and reassurances to placate the artist's distracted temper, especially in regard to the abandoned Julian tomb and the accusations of the Julian heirs.

The Seravezza experience alone would have justified Michelangelo's ambivalent attitude to the paternal authority of the Medici: but it is obvious that there were deeper reasons for the alternation of republican enthusiasm with the utmost correctitude in his dealings with that ruling family. While he befriended the Florentine exiles in Rome, with a turn of events he was quickly carried into the train of perfect prudence, primarily out of fear, no doubt, which had prompted his various flights from Florence and Rome (he made the first when Medici rule was in danger), but also, I think, because some friendliness to the Medici, as well as servility and hostility, had been experienced in earlier days when as a youth he had lived for some

years in the palace of the Via Larga, at first under the patronage of Lorenzo the Magnificent. Some thirty years later he stopped working in the Medici chapel in spite of new money offers by the harassed Medici Pope, Clement VII, fresh from imprisonment following the sack of Rome, became, instead of sculptor, the master of fortifications in the service of the revived republic. Not long after the city fell, Clement protected Michelangelo again.

We might have further insight into these events did we possess more knowledge of the year that Michelangelo spent in Bologna after his first flight from Florence in 1494, when he thought there was some danger that the French might advance on the city. He lived in the house of the Bolognese nobleman, Aldovrandi. Free of the paternalism of his home town, the young Michelangelo may well have exhibited in less tortured fashion his desire to please, to placate, to charm even, the undercurrent of the later gloom, touchiness and revolt.

It is no surprise that Leo X, the first Medici Pope, son of Lorenzo the Magnificent, preferred to employ Raphael at his court. Leo spoke of Michelangelo as a brother, almost with tears in his eyes, since they were brought up together (in the Via Larga palace), wrote Sebastiano del Piombo to Michelangelo: 'But', he added, 'you frighten everyone, even Popes.'[19] Leo is reported to have said of Michelangelo, 'He is terrifying, one can't get on with him'.[20] Ludovico, we feel, may have said the same. The unreliability of patrons, if only their unpunctuality in financial matters, often echoed the character of the father.

As time went on Michelangelo was fearful of his own crustiness in minor matters. His distaste for chatter and conventional compliments was not kept to himself: in the 1540's in Rome, he would sometimes ask his friend Luigi del Riccio to be polite on his behalf to an important person, or to return thanks for him (e.g. M. pp. 480 and 498).[21]

The final patrons were the Popes, who entrusted him with the

rebuilding of St. Peter's[22] as well as with the frescoes of the Last Judgment and of the Paoline chapel. When he was appointed architect-in-chief in 1547, he would not accept a salary for St. Peter's: through the Pope's mediation he was now employed by God; and although for reasons of policy, his interests or properties in Florence in chief, he gave polite consideration to the entreaties of the ruling Medici, Duke Cosimo, although he hankered after his native town, even sometimes fooled himself about his return when writing to his nephew or to Vasari, he was mainly committed to the unruly job of supervising St. Peter's, surrounded by enemies who tried hard to dislodge him. Dedicated at last to a single, everlasting Patron, he could at an advanced age surmount the intrigue that perpetually harries the life of an impresario. The beatified Ludovico had joined with his Maker, and so, with the earthly vicar. There could be little question of principal service elsewhere.

Michelangelo had left Florence in quest of the good father. The bad and dangerous Medici tyrant, Duke Alessandro, was left behind: within three days of Michelangelo's arrival in Rome, the Medici Pope Clement, for whom he had been working in the San Lorenzo chapel, died. Buonarroti republicanism was now much reinforced: it found expression not only in making common cause with the Florentine exiles in Rome but in his friendship during the earlier years with the reforming sect within the church of Vittoria Colonna. Yet he had been only a short time in Rome, while commanding the utmost favours of the new (though aged) Pope Paul III (who wanted to release him from arrangements concerning the Julian tomb that had been started by Clement), before he was planning to withdraw to a monastery near Genoa or to Urbino (Condivi) where he would be safe in the clutches of the much-feared Julian heirs.

On the other hand, prudent as well as panicky amid the uncertainties of patronage, during his Roman domicile Michelangelo would seem to have found, in the almost

continuous Papal esteem, the possibilities of a positive relationship, unusually humble, as well as on rare occasions, familiar and perhaps contemptuous, through which his overcharged attitudes to paternal authority could become more bearable.

Vasari reports that Michelangelo said: If life, bestowed by God, is good, then his other gift, death, must also be good. Michelangelo's own life appears to have been a living death, except that his art is inexhaustible. Melancholy was too extreme for happiness; nor did it allow him, even when circumstances were favourable, to be always employed on his art: but melancholy was constructive inasmuch as it drove him largely to counteract his strong persecutory anxiety in favour of the mournful impulsion to repair, to restore, to re-create, in favour of a preferable (in his case an inspired) kind of 'madness'.[23] And I think that this is the meaning of his wry boast when he wrote to his old friend Fattucci, sending him some of his poems: 'You will say with truth', wrote Michelangelo, 'that I am old and mad: I tell you there is no better approach to sanity and balance than to be mad.' (M. p. 526.)

NOTES TO PART I

1 If Michelangelo entertained such a fancy so in tune with myths then
 current explaining the incidence of great art, in tune, as we shall see,
 especially with his own art, it is likely to have become topical at the
 time he was suffering from stone, particularly in 1548 and 1549, from a
 painful difficulty in urination. Reporting the progress and relief of the
 illness in letters to his nephew, Lionardo, he speaks of the skin of the
 stone coming away and the throwing off of chips. It is apparent, on
 the other hand, that the diagnosis of stone is not considered certain:
 later, however, he expresses the general agreement that the illness
 was, in fact, the one of stone. The same suffering is reported to
 Lionardo in 1557. (M. pp. 225, 242–45, 335.)

 In a sonnet (F. p. 8) Michelangelo referred to the Pope as his
 Medusa (i.e. he turns him to stone). If this is worthy of remark, it is
 only so in the light of the next chapter upon the sculpture when I
 entertain the image of Michelangelo digging himself, or rather, the
 loved figures inside him, out of the stone, the aftermath of an over-
 whelming attack. As well as the agonies endured, the sculptures came
 to possess the strength of this assault as their own strength.

2 The same matter had been referred to five years before (M. p. 172).

3 On the occasion of Leo X's visit to Florence in 1515, Buonarroto, who
 received from Leo the title of Count Palatine (perhaps in order to

honour Michelangelo) as well as an addition to the family arms, wrote a long account of the festivities to Michelangelo (F. *Briefe*, p. 24). Buonarroto excuses this prattle: 'I know it doesn't much matter to you whether you hear about it or not.'

4 On the other hand, probably some years later when he was over eighty, he complains of an apparent mistake of Michelangelo's in no uncertain terms. It means, he says, that he will have to come into Florence from Settignano and he had thought he would never have to do it again. (*Cf.* part of an otherwise unpublished letter. Tolnay, Vol. I, p. 44.)

5 A. Gotti, *Vita di Michelangelo Buonarroti.* (1, p. 207, Florence 1875.)

6 But see note 8.

7 I give the letter of reproof to Giovan Simone (M. p. 150), another brother, as translated by J. A. Symonds on pages 225–7, Vol. I of his *The Life of Michelangelo Buonarroti*, London 1899.

'Giovan Simone—It is said that when one does good to a good man, it makes him become better, but that a bad man becomes worse. It is now many years that I have been endeavouring with words and deeds of kindness to bring you to live honestly and in peace with your father and the rest of us. You grow certainly worse. I do not say you are a scoundrel; but you are of such sort that you have ceased to give satisfaction to me or anybody. I could read you a long lesson on your way of living; but that would be idle words like all the rest that I have wasted. To cut the matter short, I will tell you as a fact beyond all question that you have nothing in the world: what you spend and your houseroom, I give you, and have given you these many years, for the love of God, believing you to be my brother like the rest. Now I am sure you are not my brother, else you would not threaten my father. Nay, you are a beast: and as a beast I mean to treat you. Know that he who sees his father threatened or roughly handled is bound to risk his own life in this cause. Let that suffice. I repeat that you have nothing in the world; and if I hear the least thing about your ways of going on, I will come to Florence by the post, and show you how far wrong you are, and teach you to waste your substance, and set fire to houses and farms you have not earned. Indeed you are not what you think yourself to be. If I come, I will open your eyes to what will make you weep hot tears, and recognize on what false grounds you base your arrogance. I have something else to say to you, which I have said before. If you will endeavour to live rightly, and to honour and revere your father, I am willing to help you like the rest, and will put it shortly within your

power to open a good shop. If you act otherwise, I shall come and settle your affairs in such a way that you will recognize what you are better than you ever did, and will know what you have to call your own, and will have it shown to you in every place where you may go. No more. What I lack in words, I will supply in deed.

Michelangelo in Rome.'

'I cannot refrain from adding a couple of lines. It is as follows. I have gone these twelve years past drudging about through Italy, borne every shame, suffered every hardship, worn my body out in every toil, put my life to a thousand hazards, and all with the sole purpose of helping the fortunes of my family. Now that I have begun to raise it up a little, you only, you alone, choose to destroy and bring to ruin in one hour what has cost me so many years and such labour to build up. By Christ's body this shall not be; for I am the man to put to rout ten thousand of your sort, whenever it be needed. Be wise in time, then, and do not try the patience of one who has other things to vex him.' (*Cf.* letter on the same events to Ludovico. M. p. 13.)

8 It is interesting to speculate on this 'turning out of the house', an accusation which the father prefers even against Michelangelo (*cf.* p. 39). Perhaps the phrase should not be taken literally. There is, however, evidence of a small incident (near in time to the accusation by the father) which may have been the grounds for Michelangelo's charge.

In a letter of 1516 to Michelangelo in Carrara, Buonarroto refers to his second wife, Bartolomea, whom he had married some months before: 'She behaves well, her manners are so good that she might be our sister. She has made a great success of everything so far.' He goes on to say that he thinks he will find that he has joined himself with a good and prudent woman: others think so too: he has felt anxious in the matter, largely because it seemed to him that Michelangelo had not been pleased about the marriage. Buonarroto wants to have his mother-in-law to stay for a month or two if Michelangelo has no objection. He is confident she will give no trouble nor add noticeably to current expenses.

Ten days later Buonarroto writes again, having had Michelangelo's reply. Buonarroto says he is surprised at Michelangelo doubting, in effect, whether there would still be room for him when he comes back. You, of course, have a better right in your house than anyone, comments Buonarroto . . .

Had Michelangelo thought himself displaced by the introduction of

the new women, it would not have been out of character. (F. *Briefe*, pp. 42–3, 45.)

9 We have seen that he would have liked his nephew to have voiced a similar exhortation. As late as 1550, Michelangelo is saying that men are more important than things (M. p. 270). The particular voice in the use of such conventional expressions may be considered to have their origin in the tones of the father. For instance, F. *Briefe*, p. 1. In this letter Ludovico refers to a pain that Michelangelo has in his side—probably an appendix pain—and says that he himself and his brother Francesco and his son Gismondo also suffer from it. There is a particular tone of concern held in common that seems unlikely to be a conventional expression only. Thus, in 1518, Buonarroto writes to Michelangelo in the quarries of Seravezza, anxiously bidding him to return: 'You must give the first thought to yourself rather than to a column . . . because everything goes on the same except life itself' (F. *Briefe*, p. 118).

10 And, of course, his mother, and probably Ludovico's second wife, Lucrezia, who had died in July 1497. It is perhaps worth remarking in view of this date that in the letter to Ludovico of 1512 already quoted (M. p. 47), Michelangelo exclaims: 'It's now about fifteen years since I had one hour of peace, and all is done to help you.' In the letter quoted above of 1509 (Tolnay II, p. 227) to Giovan Simone (M. p. 150), he reckons his miseries from twelve years back, again from 1497. This was a year after he first went to seek his fortune in Rome (June 1496). Doubtless that was the event he had in mind, but Lucrezia's death could have been a hidden cause of increased anxiety to restore his family.

 One object of Michelangelo's charity in later years was the endowment of needy but noble girls in Florence. He asks Lionardo to send him the name of an appropriate family (M. p. 270). Injunctions to his brothers, Giovan Simone and Gismondo, attest Michelangelo's solicitude, after Ludovico's death, for the welfare of Mona Margarita, a dependent of his father's.

11 The artist's bisexual constitution is always notable, but that is not to say that it is necessarily abnormal. Obviously, as well as works of art, many manly productions share the creative character of parturition.

12 It is probable that Michelangelo's father died in the early months of 1531, not long after his last extant letter of January 1531, at the age of eighty-six. *Cf.* J. Wilde, his note on p. 249 of *Italian Drawings at Windsor Castle*. Condivi states that Ludovico reached the age of ninety-two:

in his poem, Michelangelo himself attributes to his father ninety years. Since it is known that Ludovico was born on June 11th 1444, all commentators writing before the Windsor catalogue of 1949, have assumed on the evidence of the poem that Ludovico died in the late summer of 1534, not long before Michelangelo departed for Rome. Wilde's reasoning is based on an autograph memorandum, printed by Gotti (1875), which mentions the funeral expenses. Wilde noticed that later in the memorandum there are listed two sums paid out for Antonio Mini, the assistant who left Michelangelo's service to seek fortune in France in November 1531. He died there in 1533. It is therefore highly improbable that the memorandum is of even a later date, whereas the date, 1531, is most probable, before Mini's departure, especially since the first payments on the list undoubtedly belong to 1530.

This change of date for the father's death does not, however, affect the old surmise of a link between his death and Michelangelo's permanent removal to Rome in 1534. He was already in Rome from August 1532 until the early summer of 1533: he first met Cavalieri during this time. I suggest that one of the deeper services of this young man could have been to act as a substitute father. The anxiety springing from the fresh demands over the Julian tomb in 1531 and Michelangelo's overwork and new haste on the Medici chapel (Tolnay III, p. 12), perhaps mingled with an unfettered inclination to be more free of the Medici and of Florence and reinforced the old compulsion of the Julian image, once the father substitute in chief.

Michelangelo was in Rome again from October 1533 until May 1534: in September he left Florence, as it happened, for ever.

13 Savonarola, whose voice, Michelangelo remarked in old age, he could recall distinctly (Condivi), was doubtless an inner figure that reinforced the severer aspects of the father image. The thunder of Savonarola's personality, it has often been said (not his doctrines necessarily, nor his fulmination against the nude in art), may have served to swell the masterful assonance of the Sistine vault.

14 I hope it will not be concluded without further hearing that these preliminary flights of 'criticism' evolve from pure guesswork concerning Michelangelo and his father. It is the art which has given me the temerity to pronounce, in a few generalized respects, on the life, as an introduction to the art.

Michelangelo's depressive and persecutory anxiety is apparent in

many affairs of which we know. The patent anxiety in dealings with his family provide at least a good context.

15 In 1518, Michelangelo wrote in despair from Pietrasanta to Buonarroto: *Io ò tolto a riuscitar morti a voler domesticar questi monti e a mettere l'arte in questo paese*. (M. p. 137: see also M. p. 394.) Condivi relates that Michelangelo conceived the idea of carving a figure from a mountain which would be visible to sailors at sea.

16 Sebastiano del Piombo, for whose art he had regard, wrote to him: 'No one can take from you your glory and honour. Think a little who you are, and remember there is no one who can do you harm but yourself.' In Sebastiano's coaxing letters there are many such references to Michelangelo's undue anxiety and to his melancholy. *Cf.* G. Milanesi, with trans. by A. le Pileur, *Les Correspondants de Michelange*, Paris 1890.

17 *Cf. The Art Bulletin*, September 1950 and 1951. Hartt asserts that after his election, Julius identified himself with St. Peter in Chains. (He had been cardinal of San Pietro in Vincoli for thirty-two years. Cardinals were known by their churches as Shakespearian kings by their countries. . . . In view of the Julian tomb's bound Slaves, it is curious that Hartt does not forge a link for them with S.P. in Vincoli.) St. Peter's bonds were to be thrown off and amend was to be made for his denial of Christ: there would be a much-needed housecleaning and, of course, the Papal dominions were to be won back. . . . This dynamic old autocrat was, according to Hartt, the close prototype of the Sistine God the Father. Indeed, in the autumn of 1510, Julius began to grow the beard which characterizes him in Raphael's *Stanza d'Eliodoro* frescoes. (According to Tolnay's chronology for the ceiling (Vol. II, p. 111), the Creation of Adam belongs to the section executed between January and August 1511, but the Creation of Eve to the period immediately before September 1510.)

E. Wind was the first scholar to question radically the famous letter to Fattucci of 1524 (M. p. 426) wherein Michelangelo tells how he was left to his own devices in the Sistine decorative programme. Michelangelo may have been tempted to exaggerate his independence in view of the demands upon him by the Julian heirs over the tomb and the money that had been paid for it. This letter is a statement of Michelangelo's case in the matter.

A less tendentious view would ponder Michelangelo's original disappointment over the tomb which the Pope had allowed to lapse, in so far as this incident alone would have been likely to leave an

ambivalent attitude towards the potentate of the past, a tendency to discount his influence, especially a vague, intangible influence rather than one which had led to a cut-and-dried iconographic programme as envisaged by these commentators.

But I will mention some of Hartt's iconographic trappings for the ceiling. The *ignudi*, it is a relief to discover after some other interpretations, may be regarded as acolytes or servitors. The Rovere acorn garlands are identified with grapes, with wine, with the Mass as well as with the Tree of Life. (This last nexus of symbolism is the point of departure for E. Wind's interpretation.) The bronze-coloured Medallions represent the consecrated Host which in the sixteenth century was of no mean size . . .

It is not necessary to accept his interpretation in order to feel some gratitude to Hartt for reaffirming the influence of Julius on the vault.

This is the best place to refer to the same author's interpretation of the Medici chapel (*cf. Essays in Honor of Georg Swarzenki*. H. Regnery & Co., Chicago). Hartt is the only scholar to put forward an acceptable reason why the tomb for the *Magnifici* (never executed) was not put in hand instead of the tombs we have of the *Duchi* or *Capitani* who were, as great men of the Medici family, of far less importance. When wall tombs were decided upon, the *Magnifici* were allotted a monument with twin sarcophagi ornamented with patron saints but without the portraits that were finally developed for the *Duchi* monuments. In fact, the scheme for the *Magnifici* tomb did not develop far. It was to be the *sepoltura di testa* as it is called in the documents, the setting for the Medici Madonna and Saints which are to-day against that same entrance wall.

Hartt has this comment: After the expulsion of 1494, the Medici had revived their power in Rome, in the church. 'From the breast of Mother Church, the Medici family, exiled since 1494, had derived its sustenence.' (In the interests of his entirely different interpretation of the sculpture and architecture, Tolnay has pointed out that the eyes of the sculpted *Capitani* are turned in the direction of the lactating Madonna.) In 1513, Leo X, the first Medici Pope 'in brilliant ceremony had Roman patriciates conferred on Giuliano and Lorenzo (the *Duchi*, Captains of the Church) on the Capitoline hill amongst Roman trophies and Medici symbols, while Mass was said at the altar.' It can be argued that the most *representative* figures at that time among the Medici were not the *Magnifici* nor the Popes, Leo and Clement, who had commissioned the work at San Lorenzo (the tomb or tombs for

all of them had figured in various plans), but the composite Captains of the Church. And perhaps Michelangelo argued similarly in order to devote himself to a more impersonal subject that lent itself better to heroic portraiture.

Much of the projected sculpture and painting for the chapel was either not completed or never begun. It is perhaps reasonable to suppose that some of this residue, if not all (over which Michelangelo, no less than circumstances, gave cause for delay), even the River gods (to one of which he had originally given a priority) at the feet of the Captains' tombs, came to possess for him an aspect of superfluity. Leaving Florence for ever in 1534—Clement died two days after his arrival in Rome—Michelangelo himself did not see the Times of Day in place upon the sarcophagi.

Tolnay who, following up the work of Popp in particular, threaded together clearly the complicated evolution of the plans (*op. cit.* Vol. III), has this to say concerning Michelangelo's method of work. 'Starting with a traditional scheme, he was compelled by an inner urge to unfold completely all the inherent possibilities. Only after arriving at the limit of the traditional solution did he impart a new spiritual content, transforming all the existing elements. This was the development of the Sistine ceiling . . . and of the Last Judgment, which he first conceived as a representation of the act of judgment only to transform it into a revelation of cosmic fate. He always conceived his ideas on the basis of Renaissance conception, but, not content with this solution, was in each case again and again compelled to re-create his works according to his new idea' (p. 40).

18 *Cf.* F. *Briefe*, p. 77. Buonarroto says he is glad Michelangelo is taking on the San Lorenzo commission because it appears that the Medici are well on top of the world again. But Michelangelo must see he gets good pay for all his work: Buonarroto reminds him how easy it is to be side-tracked by these exalted persons.

19 *Les Correspondants*, p. 21.

20 G. Gaye. *Carteggio inedito d'artisti dei secoli XIV, XV, XVI.* Florence 1839–40. Vol. II, p. 489.

21 The excellence of Michelangelo's manners is attested by Donna Argentina in writing to her husband Malaspina, Marquis of Fosdinovo, in 1516 (F. *Briefe*, p. 28). *E persona tanto da ben costumato et gentile et tale, che non crediamo che sia hoggi in Europa homo simile a lui.*

22 Bramante, the rebuilding of St. Peter's, had originally caused the

blasting of his hopes for the Julian tomb. There was justice and recompense for him in being charged now with the making of the new church. Instead of Bramante's insistence upon a clear-cut, self-sufficing entity, Michelangelo, though he valued Bramante's style (M. p. 535), invented a more turgid image.

23 He once answered the hyperboles of an insignificant but ambitious admirer (Niccolo Martelli) with these words among others: 'I am a poor man of little worth and I want to wear myself out in the art which God has given me, in order to prolong my life as much as I can' (M. p. 473).

Part II

Visual Works

VISUAL WORKS

It is likely that images of the body belong to the æsthetic relationship with every object; emotive conceptions of physique are ancient in us; awareness of our own identity has always been based upon the flesh; the outer world of objects was conceived in the first place almost as an extension of our bodies. This early view, of course, bears no resemblance to an adult impression. But art tends to return some of the way back to the sources of feeling and perception. If we could put ourselves at the service of Michelangelo's genius, we should find that he illuminates strongly the compulsion in all art.

He was obsessed with fantasies of weight: he discovered in weight and movement imaginative media not only for depression and death but for the health of physical power. Momentum conquers, flows through complex attitude, the fount of all episodes, the massive idiom of self-mastery and self-possession. This weight, as well as the supporting naturalism of the early works, impels the spectator to exclaim over Michelangelo's figures that they are 'larger than life'. Plasticity, in particular of

the male nude, had for some time been the principal target for Florentine figure painting and sculpture. If Michelangelo's works astonish us to-day, an impression got from them of crushing aside other art (as well as ordinary living) was stronger for his own time: in fact, there has not existed another artist who thus overpowered his contemporaries during a great age of art, magnified in stone the hidden fibres of any superlative strength they aspired to possess.

Plate 1 shows the Redeemer of the Last Judgment. He half rises: his arms are flails. Wide as an ape, with electrifying precision he ordains parcels of humanity to the distant zones. He governs in himself an ethereal density, the colossal weight which would belong even to a match-box were it filled with material from the centre of the sun: yet he is brisk, gymnastic; the order and disorder of the hair suggest a serpent-quick intelligence . . .

The energy of this lavish flesh takes us unawares; we who are surveyors of Easter Island and of the dented meteorites of our own art.

Critics agree that Michelangelo's power is unparalleled, not only for the vigour of what he made the nude express (as a rule with the help of distortion), but in regard to his representational skill. Elements of tautology linger in both judgments, because it is not always apropos to differentiate during the Renaissance between skill, visual memory and genius. We cannot think that that situation is likely to recur: we do not feel that the musculature of the nude can again become the vehicle of a comparable significance. The reasons are many; cultural, formal, iconographic, some of which I shall discuss. But first there are even wider matters, useless as targets for scholarship in view of their vagueness; for example, the light, the climate of Italy and, in relation to them, the more profound sources of architectural stimulus. There is, for instance, a common sensation on reaching a Mediterranean country that an attendant oculist has slipped in

lenses that clarify: an object even at distance is cleared of film: envelopment has sprung away. The distinctness, the palpability, seem to show that things are well. Ordinary Italian buildings offer us this bounty from their homogeneous walls pierced by apertures of an acute darkness, by a sable inner world inspiriting connective tissue, walls, tiles, cobbles, shutters. Michelangelo inherited not only the achievements of Giotto, Masaccio, Donatello, Antonio Pollaiuolo, Jacopo della Quercia, but more widely the Renaissance gusto for material seen with a clear lens, the passion for conceiving an individual physique however idealized by art, a particular scene however allegorical, as attainable, touchable. By means of the articulated nude he, in turn, contrived a touchable and heroic universe, a touchable homogeneous condition, the outcome of conflict. For, whereas æsthetic creativeness is rooted in the passion to obtain sensuous particularity for emotion, there supervenes an earlier experience whereby the world is one. Quattrocento art prized the newly-born, the *singular* object of the senses, yet singularity itself pointed to, or included, an all-embracing character: under the hands of fifteenth-century sculptors, the stone blossomed as if subject to the steadiness of *all* rooted living forms.

Though his achievement would have been impossible without the prevalence of so dynamic a conception in the previous century, Michelangelo modified the dominant Renaissance fantasy concerning the stone. As well as contriving so that a markedly individual shape should emerge, a near and loved thing such as the fifteenth century conducted to the light from a rich medieval soil, he partly re-interred the new-won finite world, no less than the antique, just dug from the Roman ground, in the homogeneous block. In saying this I have in mind not only the expressive lack of finish of the later sculptural works but also the High Renaissance shift from the Quattrocento enjoyment of outward things, in favour of more masterful organization. 'Michelangelo, the greatest of all naturalists', wrote Wölfflin,[1] 'was also the

greatest idealist. Equipped with all the Florentine gift for indi-
vidual characterization, he was at the same time a man who
could most completely renounce the outside world and create
solely from his own conceptions: he created his own world and
it was his example—though not his fault—which chiefly led to
the lack of respect for nature which was shown by the next
generation.' And so, Michelangelo's inherited theme of the nude
must be estimated as an emphasis upon the outwardness of
the physical (the Quattrocento inheritance) and also as a gener-
alization (of individual character or emotion) favouring a sig-
nificance so comprehensive that any stone block is felt to be a
parallel sign. Nevertheless he was the supreme carver or vivifier
of material: he aligned modelling with painting. (Cf. p. 98.)

Antique art, to which Michelangelo greatly attended, is, of
course, restricted, modest, less aggressive than his work. One
will ask: of what is the Antique, the prototype; of anatomy,
proportion, ideal beauty? Often it so served in serving more
generally as a prototype of the aim of art. The fundamental
lesson has surely been the one that Pater revealed in *The Renaissance*
when he wrote of 'this ideal art in which the thought does not
outstrip or lie beyond its sensible embodiment'. Classic visual art
is concerned more directly than other art with the human form,
the most sensible vehicle of feeling; with landscape, with archi-
tecture, as comments upon the inescapable presence of the nude.
Thus, in sculpture, we are never distant from a notably physical
presence or particularity in the service of an idealization, or even
sometimes of a passionate mysticism that will not proceed
beyond the bounds of undistorted embodiment. The result is an
easy naturalism and a disciplined use of general terms.

If the definition fails to enclose even Michelangelo's recurrent
adaptations of classical themes, it is not because he is not found
there, but because he extends beyond. We shall often have met
conflict conveyed in art with equal or even greater intensity, but
we shall not find a parallel for his idealization that electrifies

without disrupting a classical embodiment. It is Hercules, they are heroes whom he tortures: until his last works an extreme health contains and conquers the everlasting tension of which he made a nude the vehicle . . .

Now, it is easier, surely, to find order in the stars than a permanent beauty of the flesh. Science leans towards the extinction of feeling, art towards beginnings that endure.

Plastic values, tactile values, we have been told, enhance the sense of life. But how are the æsthetic forms health-giving, life-giving? Certainly, perceptions will be flattered by their enrichment in the contemplation of art; but such partial flattery is nothing: messages from great art are not the means of a tremulous rejuvenation. There is something more precious than youth with which it may easily be identified; namely, the hope, the ideal, the comfort and self-esteem, whatever the forms it takes, without which we cannot be healthy: some hold on goodness whose sources were loved incorporated persons, as if part of ourselves but not ourselves, *ingested from the outside world*; in the first place, therefore, physical objects; that body—the original attributes will have been transvalued almost beyond recognition—which many a suicide even, may want to preserve in destroying the enemy, himself.[2] . . . Works of art proffer a magical reassurance, as if a house were supported not only with defensive walls but with the nearby trilling of a nightingale . . .

Michelangelo's drawings make us acutely aware of the body's articulation. As remembered impressions fuse, a state may arise that in a 'philosophical' form suggests the imprecise eroticism not uncommon in dozing. Though sharing the same root, this state is not in fact erotic in the popular sense. An identical, if less vivid, awareness of articulation may be had from all fine pattern, and particularly from architecture. Moreover, it is as if any physical need that such awareness must ultimately imply, embraced all others; as if, in a far-removed form, we experienced again the earliest goodness of the sensuous life, the blissful aspect of the

mother's body (or part of it) co-extensive with an outer world which we incorporated (together with the bad), though afterwards retaining it without as well.

Also this retention without has provided a necessary idea of goodness: the desire for the good body, as expressed by art, is equally a desire for its *separate* persistence inside and outside ourselves, a quality I shall try to enlarge upon.

Meanwhile we are for the moment in the Uffizi, in a long gallery of classic nudes at which we look up, jostled by a crowd whose individuals are even rather repulsive to each other, sickening each other of the flesh. The sculptures, and paintings in adjoining rooms, the Florentine nudes among them, persist no less coolly in their appeal: they have little in common with even the most delightful members of the crowd who are uninteresting in this manner; that is to say, not immediately interesting in this manner, not so strikingly. Beyond the Uffizi, in many stretches of Florence, on the hills among olive terraces, still, level, lit arcades immemorialize the human frame; their thickness records firm integument, windows eye-sockets, cornices the uncontracted brow, ageless yet of each age. From the contrasting roughness of roof and of surrounding trees, plain plastered houses offer a ready image of the body in the manner of a nude revealed by the undercut drapery of surrounding figures in a fifteenth century relief. A similar alternation comes to us now from every object. We glance at the terraces dominated by sleek cypress, or at the light from the chinks of the plumed cypress edge: we turn to the filigree olive trees and the drop between the levels. We turn once more to building: arches now provide a day-lit reassuring version of the entangled members in Michelangelo's Centaur relief: owing to a uniform emphasis on this façade, all surfaces and crevices are unusually manifest, as if attentive: shells on architrave, frieze or spandrel are ears: steps the grooves of the body that mount to the lips. Nevertheless, though declared in terms of such analogies belonging to a more

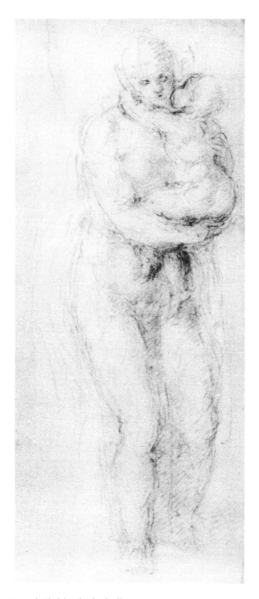

9. The Virgin and Child. Black chalk

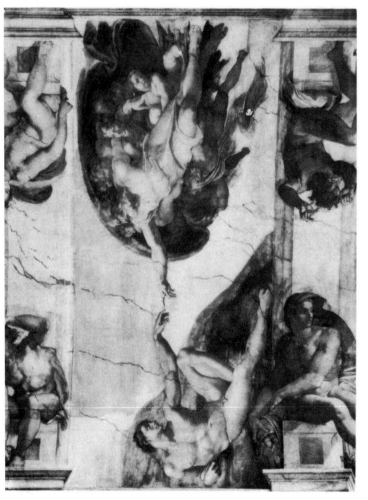

10. The Creation of Adam. Fresco

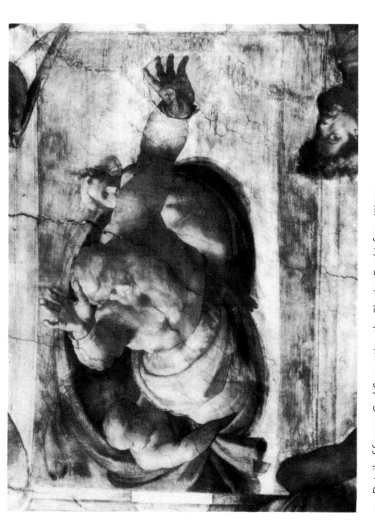

11. Detail of fresco, God Separating the Sky (or Earth) from Water

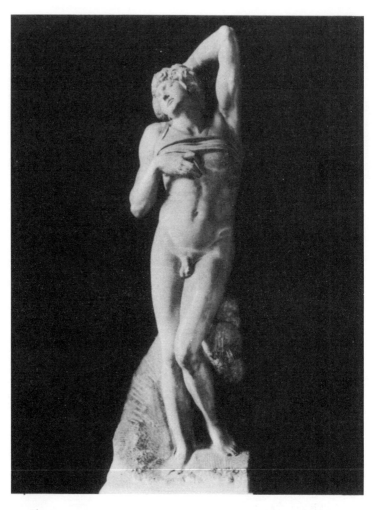

12. Slave

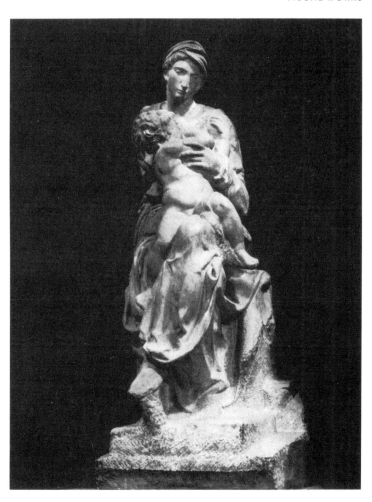

13. The Medici Madonna

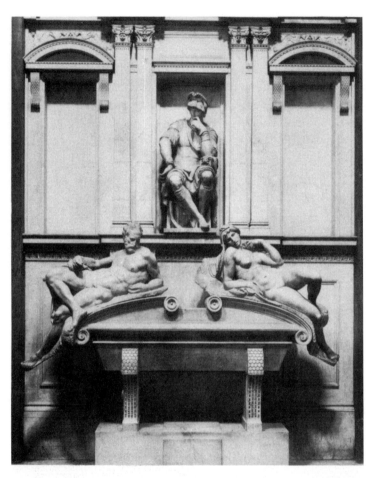

14. Dawn and Evening

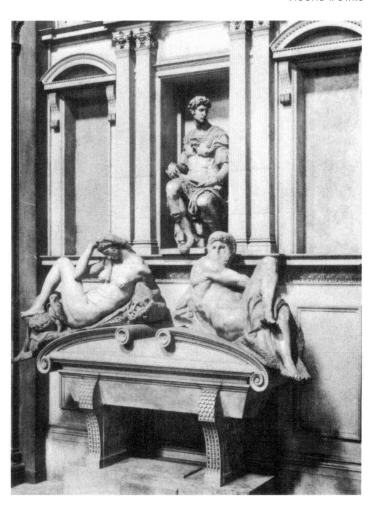

15. Night and Day

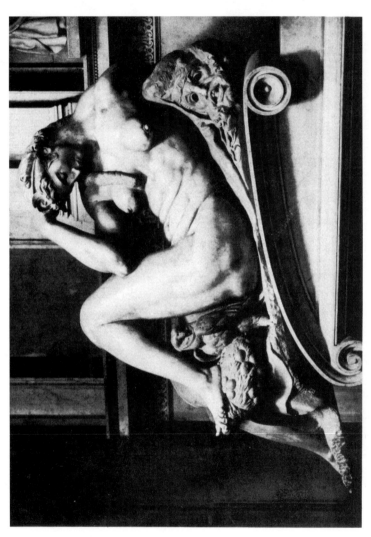

16. Night

mature existence, here is the body for ever and the final face, not the dear, not the loathsome body, but an image of the flesh before repugnance has been brought into line, image of refuge, sustenance, sought with a relish we shall never surpass.

I suggest that the old richness is renewed by the imagery of contrasting textures, even though in the æsthetic result, texture may play only what is called a decorative role. The basic architecture of the visual arts depends upon the many alternations such as repose and movement, density and space, light and dark, that underlie composition, none of which can be divorced initially from the sense of interacting textures. Æsthetic appreciation has an identical root: it is best nurtured by architecture, the inescapable mother of the arts. Indeed, the ideal way to experience painting in Italy is first to examine olive terraces and their farms, then fine streets of the plain houses, before entering a gallery. As far as the streets are concerned a similar procedure can be recommended for Holland in preparation for Rembrandt and Vermeer. It is not a coincidence that what we now call Old Amsterdam was rising above smooth water in Rembrandt's day. Much existed on his canvas, in the character of the surface, before he started to particularize, to paint.

Now, if we are to allot pre-eminence in æsthetic form to an underlying image of the body, we must distinguish two aspects of that image, or, rather, two images which are joined in a work of art. There is the aspect which leads us to experience from art a feeling of oneness with the world, perhaps not dissimilar from the experience of mystics, of infants at the breast and of everyone at the deeper points of sleep. We experience it to some extent also from passion, manic states, intoxication, and perhaps during a rare moment in which we have truly accepted death; above all, from states of physical exaltation and catharsis whose rhythm has once again transcribed the world for our possession and for its possessiveness of us; but only in contemplating works of art, as well as nature, will all our faculties have full play, will

we discover this kind of contemplation in company with the counterpart that eases the manic trend. I refer to the measured impact of sense-data that distinguishes the communicating of æsthetic experience from the messages of ecstatic or dreamy states: I refer to the otherness apprehended in the full perceptions by which art is made known. An element of self-sufficiency will inform our impression of the whole work of art as well as of turned phrases and fine passages. The poem, the sum-total, has the articulation of a physical object, whereas the incantatory element of poetry ranges beyond, ready to inter-penetrate, to hypnotize. Or perhaps precise and vivid images, an enclosed world fed by metre, serve a sentiment that is indefinable, permeating, unspoken.[3] Space is a homogeneous medium into which we are drawn and freely plunged by many representations of visual art; at the same time it is the mode of order and distinctiveness for separated objects.[4] Musical *ensembles* create perspectives for the ear: as well as the 'music', the enchantment, the magic, there is the *exactness* of rhythm, harmony, counterpoint, texture, and the enclosed pattern of symphonic shape, handy as a coin. We are presented with discipline, articulation, separateness, and with a blurring incantation that sucks us in, at the same time, gives us suck, communicates, however staid the style, a rhythmic flow. The strength of these effects will differ widely, but the work of art must contain some argument for all of them.

There is, then, in art a firm alliance between generality and the obdurate otherness of objects, as if an alliance, in regard to the body, between the positive rhythmic experiences of the infant at the breast and the subsequent appreciation of the whole mother's separate existence (also internalized), complete to herself, uninjured by his aggressive or appropriating fantasies that had caused her disappearance (though it was for one moment) to be mourned as the occasion of irreparable loss: there is the suggestion of oneness, and the insistence on the reality of

otherness if only by the self-inclusive object-character of the artefact itself.

And so, these good and reassuring experiences, the basis of object-relationship, are used æsthetically as the cover for all manner of experience (i.e. they inspire conceptions of style even those predominantly hieratic or anti-corporeal and abstract, govern the treatment of subject-matter). This is the practical idealism of all art which says 'in order to live we must somehow thrive'. The artist is compelled to overcome depressive fantasies by making amend (often, as in the Renaissance, by presenting with an air of ease the surprising and the difficult), the amend that articulates together an all-embracing physical entity with bodily separateness, reconstructions of internalized good objects, threatened by the bad. Content, subject-matter, may be unredeemed; formal magic must rule over the pressures of culture. Obviously, art is not planned on tactics of avoidance. The artist has recognized our common sense of loss in a deep layer of his mind. Michelangelo, it is manifest, forged beauty out of conflict (not by denying conflict). The disguises of art reveal the artist; they do not betray him. It can less often be said of the activities of others.

These abstractions may not be so unfamiliar. The above conception of the Form in art has kinship under the modern dress with some well-known aspects of Renaissance theory, the emphasis on the human figure, on the proportions of the nude as the basis of all proportion including those of architecture; the welding of observation, of respect for the particularity of objects, set in space, with a mathematical or Neoplatonic homogeneity.[5]

Although the recalcitrant material of which the earth is made, possesses the highest degree of separateness from ourselves, it should now be clear that in the phrase, 'the homogeneous block of stone', there is implied an image of all-inclusive *oneness* as well as of individual *separateness* so literally exploited by sculpture,

especially by small pieces that we may handle. Absorbing Michelangelo's sculpture we seem able to fondle eternity in terms of physical tension and movement attributed to the nude.[6] The stress he achieves upon the absolute, comes to us from an object that stands well away from us even though we ourselves are subject to that all-embracing significance: and this is so not merely because the marble stands outside us but because Michelangelo's expressionist aim was for the most part subject to the self-sufficiencies of a classical style; because his exaltation of the nude was still largely based upon classical precept; because, in short, the heroic, naturalistic nude served as the vehicle of his longing for universal non-differentiation which so many have rediscovered in a less masterful form, by playing down the precise world of the flesh.

But if this is true, it is also true that we are very conscious of Michelangelo's romantic sense of conflict and of the reference that each form brings to the warmth of his attack upon the stone: whereas in the case of an opposite master, let us say Piero della Francesca, in the case of his love for separate particularity and exact position, we are first aware not of the artist's vital handling but of the intercourse between the forms on which he has insisted, and so, thus impersonally, of an autonomous yet personal world. It contains a calmer, less aggressive yet more concise conception of oneness, less compelling because unemphatic, by no means less noble. Even after allowing for the differences between the two periods from the point of view of art history, Piero, we feel, was not a restless man: he exalted wholeheartedly the out-thereness of things.

Michelangelo turned little to landscape and not greatly to the sublimities that entranced Piero of mathematical proportion.[7] Though science and art were close in the Renaissance, it could be said that Michelangelo was not by inclination a scientist, even in the broader sense, in spite of his enormous responsibilities as an architect. But that might be a misleading suggestion. He

persevered with dissection though it tended to make him ill, at any rate in old age (Condivi). No artist, unless it be Leonardo, has equalled his perception of bodily structure in relation to every kind of movement, a knowledge of which his mind was most retentive.[8]

All have shared with him a very early, primitive identifying of sense-data with feeling: moreover, whether it leads to the exercise of art or to skill in other fields, deftness, dexterity, is from the earliest times the use of a vital rhythm that keeps the good object going and harnesses the aggression against it. The artist shows himself, generally in both respects, unusually tenacious. Michelangelo's subsequent development points to a power of memory and a grasp so long informed with intense visual images of actuality as the media for divergent emotions—the distinctive part is the (visual) artist's compulsive grasp of some exactitude, of structure, spatial disposition, weight: it separates him from the mystic—that we have no compunction in accepting the legend of his draughtsman's virtuosity as a boy. He appears before history almost ready-made, it seems, in Domenico Ghirlandaio's *bottega* at the age of thirteen.

(For the most part I treat only of the less immediate sources of his art whose manifestations were, of course, dependent upon a thousand factors of his time. Had he the misfortune to be born in our own epoch, we might have possessed a variant Picasso, an equal artist of disorientated force.)

But in stressing Michelangelo's impersonal observation of the mechanics of the body, we must not seem to minimize the hallucinatory, the aggressive, appropriating side of the matter, more evident in his case than in the case of an artist such as Piero, or even Poussin with his enclosed world that provides a fencing to the masterful promptings of his temperament. Nevertheless, if Michelangelo's visions elbow, rather than persuade, ordinary existence into the road, it is not at the expense of his own æsthetic inheritance. Supreme initiator though he was,

room enough remained for all supernal antics in the classical amplitude of that time: little need existed for the descent into what we now know as the subjectivity resulting from the weakness and confusion of styles.

The wonderful sheet of drawings in red chalk at Windsor of Three Labours of Hercules (Plate 6), an independent work of academic aim, probably a presentation sheet (Wilde), will serve as an example, by no means extravagant, for the Michelangelesque articulation and weight. It is especially revealing to remark stresses of this kind in so finished a drawing; for instance, the heavy thigh and back of Antaeus, a downward growing trunk, as it were, of which the leg below the knee is but a branching twig. The composition in the three episodes is markedly involuted. But the muscular stresses of these nudes, slow, inexorable, yet coiling, as we feel, to some attainable pyramid in harmony with the theme, link them with the tonicity that nourishes the fatalistic poise of the Delphic Sibyl or the Moses. Even from this drawing which emulates the antique, we derive the feeling that we are within the realm of the Sistine Isaiah, Jonah, Joel, or of the Sistine *ignudi* who have lifted themselves from the ruck of muscular torsion. Daniel and the Libyan Sibyl have these labours behind them: they are bastions who astonish us by their capacity to reign over their own voluminous thrusts. The Sistine Eve, most feminine of Michelangelo's nudes, is the princess of a people whose supporting toils are mirrored by the iridescent involutions of the serpent; by those thick spiralling elaborations on the surface of the tree, which cause Eve's body and her open face to appear the more succinct. In the expulsion on the right, the angel's flat triangular sword to the neck of Adam, a shape that answers dramatically to the stretched arms in the Fall, demonstrates the sharp future toil . . .

Michelangelo exchanged guilt, fixation, depression for the dynamic if slowed-down bodies of contrite heroes with strength and more to match. With gross pain just behind them, he

showed that their brooding strength must build a huge reserve of matchlessness. He was, of course, incapable of avoiding optimistically such conviction, the basis and spring of his art; an art supported by deep religion.

In the sculpture, heroic figures emerge from, yet relapse into, the homogeneous block. But before discussing Michelangelo's relationship with the stone, it will be useful to consider drawings: in executing even the studied Labours of Hercules to which I have referred, the draughtsman was not forgetting the tissue of stone. The limp, overpowered lion's mane, the lion skin foaming from the shoulders of Hercules in the first episode, the touched-in Hydra of the third, are like layers in the marble which Michelangelo often left chipped, allowing to the nude a heightened, smooth presence. The alternations of light-and-shade, we have said, while serving to articulate the figures, provide also a means of realizing textures. The technique of this drawing varies from stipple to hatches; *laborious* marks, we feel, whereby such figures of stress materialize, as if marks that record the carver's image of movement prised from the stone, were the close counterpart to the muscular effort he used in making them.

It has been said of late drawings especially, of a period when Michelangelo's touch had become unsteady owing to his great age, when his eyesight was defective, that he gradually worked inward from many corrections of contour lines, being compelled to narrow the form. However that may be, it was surely natural that he should start with breadth; so that there has come about by means of the *pentimenti* a suggestion not of distance but of the circumambient stone. Especially in old age the chalk in his hands tended to reproduce the preliminary scorings of the sculptor.

No one suggests that the work of Agostino di Duccio has any direct connection with that of Michelangelo: and yet, in spite of their lesser gravity and weight, it is not absurd to be reminded of

the reliefs at Rimini by a late drawing of a nude Virgin and child (Plate 9) in the British Museum (Wilde 83), in preference to any other comparison other than further late drawings by Michelangelo himself. For it happens that although Agostino may be considered a mediocre artist in other ways, he was inspired by an intense and compulsive attention to the smooth-and-rough of the stone which sometimes inspires the artist to disclose forms that seem to undulate there, to provide us with a poignant image for the sense of universal growth. Many Michelangelo drawings, and particularly his paintings, of course, are noted for the sharpness and hugeness of their relief: it will therefore appear strange that Agostino, master of marble low relief, should be mentioned in connection with him. Yet this very mature work, perhaps the latest surviving drawing, obtains the closest contact between mother and child; and, just as the child is embedded in the mother, so she herself is embedded, it appears, in a homogeneous material which discloses her form, as might the adumbration of drapery.

My point is that if Michelangelo had not shared at times this quality of feeling with Agostino, he would not have been the greatest of sculptors and among the greatest of draughtsmen.[9]

The use of light-and-shade to suggest texture (smooth-and-rough) is well seen in the famous finished drawings of the Archers (Plate 7) and of Tityus with the Vulture. We have in the first a wonderful pattern of great depth: the animus, so to say, in the anatomy of the figures in their rush to the right, would hardly strike our minds were the heads not matted like flowers upon long torsos and limbs. The arbitrary shadowing of some of the forms serves the same feeling. As for the Tityus, the recumbent body is clearly indebted to the feathered scales of the devouring vulture, as well as to the uneven rock and the gnarled tree. And surely the same mastery governs Michelangelo's crowd scenes—no other artist has had such success in suggesting turmoil, closeness, interlocking, accompanied by some

separateness—in the Centaur relief, for instance, in studies for the Worship of the Brazen Serpent, in the Symbols of the Passion at the top of the Last Judgment, and so on; an intensity, a sweep, to which the Baroque artists, in spite of more sensational devices, aspired in vain. Michelangelo could supply contrast from the texture of each body; there was no need to relax a wider stress. We feel that he could evolve such scenes from scribbles with pen or chalk which enclosed islands of the paper; marks, together with the paper, soon represented actions of the human frame; not only pattern but potential rudiments of precise flesh. In this he would have differed only in degree from any other representational draughtsman. The sense of form expands from the sense of texture whose sharpness depends upon an unusual reactivation of the images for the bodily merging and the bodily separateness, defined above.

While there could be no better diagrams of the smooth-and-rough than Michelangelo's late carvings of the Pietà wherein the smooth body of Christ is backed or flanked by rougher supporting figures,[10] it will seem unusual to find the sense of this architectural dichotomy prominently displayed upon the Sistine vault. And yet, on returning to the Sistine chapel we are not so much overwhelmed anew by Prophets, Sibyls, Histories, that can scarcely be forgotten. There comes to the revenant a more permeating impression of the whole: he is gazing at the most successful decoration ever conceived: he notices an emanation of rosy light: each tempestuous figure has a place; there is large arrangement of light and dark, particularly the high lights on the centre of the painted arches and the jagged carry-in of light between Adam and the Creator at the top of the vault: little crowding results from so much figuration. Indeed, the Sibyls and Prophets, biggest figures by far, positioned at the top of the walls as if supporting the vault, not only prevent the apex from appearing overcrowded, they assist also the fancy that this painted ceiling grows from the

painted walls as might carved reliefs from their backgrounds. The white tone of the painted architectural framework dominates: but the impression is architectural because although vast surfaces are painted with figures, we viewers are subsisting none the less in the realm of aperture and projection, wall and void, of rough and smooth, the constant theme of architectural effect. We can justly compare the interplay between the bronze-coloured Medallions on the Sistine vault and its rectangular compartments (wherein the Medallions reappear in the forms of sun and moon), with the interplay on the Capitoline buildings, designed by Michelangelo, between pillars in association with giant pilasters, and the wide rectangular openings.

Many eminent Florentine painters and sculptors of the fifteenth, sixteenth and even seventeenth centuries were also architects. Vasari, himself an architect-painter, allows no fundamental difference between the visual arts. The root of all is what he calls *disegno* or drawing; but drawing in the sense of a power to elicit structure, to compose, to bind, to order, to harmonize differences, to proportion weight, to build.[11] No one will deny that the basis for this art was a thorough advertence to the human frame, to the nude, the bony structure, the balance, the protuberances, the cavities, the hair; a corpus of applied knowledge, however, which, thus extending the lessons of the human figure, unconsciously endowed with all these many dignities the ambivalent infantine experiences of orifice, crevice, enfolding embrace; of members that project, tautness and rotundity, of the hunger-filled and the contented mouth; in short, whatever sensuous experiences were primarily associated with the hard nipple, the milk and the soft continuous breast, as well as with the mother as a separate person.[12]

Now architecture, the more abstract of the visual arts, can afford to dignify those experiences with less disguise: there exists here a more profound significance for the phrase 'archi-

tecture, mother of the arts', a meaning applicable not only in Europe; and whereas entire commitment to the human proportions was rarely possible in practice, *disegno*, generally speaking, betrays its architectural root, the influence of houses in which men live.[13]

Deep emotional concern with buildings entails the predilection for a rectangular framework. (Pictures have always had architectural setting, whether frescoes or easel pictures with frames.) Even Michelangelo's *contrapposto* is based upon squareness in conjunction with circular forms. The more worked the drawing the clearer this becomes, at any rate in middle period and late drawings; for instance, the famous Bacchanal of Children. One will hardly fail to remark the strong rectilinear design—an entire block, as it were—of the *Epifania* cartoon in the British Museum, and the significance of the rounded heads. Or we may consider a collateral of the waistless Redeemer of the Last Judgment, the nude Virgin with child (Plate 4), (Holy Family with infant St. John, Wilde 65). The attitudes are complex, yet the robust columnar bodies leave another image on the mind, a suspended fleece weighted with gold. The conception is sculptural, and sculptural in the sense also of architectural, in the sense of alternations imposed upon an accurately divided block. Plate 3 is of an early sketch, perhaps from the time of the Sistine ceiling (Wilde). First the rectangle of the paper, then a nest of lines, supple as green twigs.

A late variant of this motif is the cat-like yet square palpability of the Fitzwilliam Christ, or the design for the Christ and the Money-changers (Wilde 78 recto). The Last Judgment, the leaden ballets of the Paoline chapel frescoes, particularly the conversion of St. Paul, demonstrate how rich and multiple was this theme. The centre explodes into rectangular depths.

Such themes are common enough: the point is the urgency and inspiration they receive from Michelangelo. Shifting the cube so that the longer side is vertical, Michelangelo drew

versions of the Resurrected Christ (Plate 5), elongated, shot heavenward, the sketch for the soldier at the Resurrection in the Casa Buonarroti, the sketch there of the Christ in Limbo. (The motif was evolved much earlier; it is seen in a sketch for the Raising of Lazarus at Bayonne, executed for the use of Sebastiano del Piombo, about 1516.)

The stone is opened by the sculptor, robbed, restored, transformed. Sometimes in the late drawings we may feel that excoriation stops in favour of a Quattrocento caressing; that the pluckings-out of spiral and oval, womb-like, forms from the rectangular framework, cease. The form is good and unrobbed. . . . What rounded words this Virgin has from the angel at her ear. (Plate 8, Wilde 72 recto.) The square shoulders, the bent arm on the table top, the rectangular pattern of a soft, voluminous shape, seem effortless, glowing. There is often the same poignancy where Michelangelo has emphasized—as sometimes from the earliest days—the roundness of the head: though massive, it remains the more tender of his plastic inclinations. The well-woven words, as we feel them to be, at the ear of the Madonna suggest for the design a quality of contentment even, a mood in which Michelangelo may sometimes have come away from conversing with Vittoria Colonna. He depended on her high-born piety: doubtless in company with that dependence there existed the wavering belief that he, Michelangelo, put goodness into her: and it is likely that a rare conversational encounter of this kind was the nearest approach he could make to marital enjoyment.

The famous lines in Michelangelo's sonnet (F. p. 89) reveal the conviction that the sculptor projects no absolute form: his skill and imagination are needed to uncover something of the myriad forms the stone contains.[14] He removes the twigs which conceal a bird on a nest. (Cf. the basin which in the London drawing (Plate 5) serves as the sarcophagus from which the resurrected Christ darts up in flight, Wilde 52.) As well as fan-

tasies of propinquity we may expect in the context of carving, fantasies parallel to those of exploring the inside of the mother's body, perhaps of snatching a future rival from her womb or of appropriating a fruitfulness that the aggressive infant cannot otherwise attribute to himself. The attack goes on in sculpture, blatantly, one might say, since it will not be mastered unless fully accepted. The form in the stone must first be released or stolen, then exalted. It is as if while discovering the whole, much longed-for object, the infant were able to perpetuate this vision by those very same aggressive fantasies, perhaps of robbing the fruitful womb, which have contributed to his sense of loss and to his need of making restitution. Art is what it is from the character of being an act of reparation that may employ the entire contradictory man. The sculptor controls a rich hoard, animates at the same time an obdurate dead material, a catastrophic avalanche, 'He breaks the marble spell' according to Michelangelo's sonnet; on the other hand, much of his sculpture seems to state that the outer stone is not to be considered as mere husk: it too has forms in embryo.

Even in early, more finished works, he chose to preserve some evidence of the original block: the tendency grew to leave surfaces uncut or roughly cut. The homogeneous block could be homogeneous in a manner he valued, whereas the particularity of any form prised out of it became, after a certain advanced point, less complete as it was 'finished'.[15]

In circumstances that might have entailed paralysing uncertainty, Michelangelo pressed on to solutions (aided by chance) of which the world remains in awe. Of his genius, the enduring strength of his vision, we can only remark feebly, tautologically, that his grip on life was thus strong. He valued in sculpture parts of the rough stone that will collaborate in revealing the particular nude; uncover the emotional process of searching the block; add to depth and vivification; allow the worked forms to suggest both emergence and shelter, a slow

uncoiling that borrows from the block the ideal oneness, timelessness, singleness of pristine states.

I should have liked to offer a description of the Pitti Madonna; but photographs do not convey the saucer-like tilt—it helps to give the head great prominence—at the bottom of this circular relief, nor the varying treatment of the rim. Volume is attained by an extraordinary subtlety of levels and depths: the Virgin sits on a cube that appears to be cut from the original face of the stone (it projects beyond the inner rim, though not as far as the corresponding block of the Virgin's head), the receding planes of which have been left rough, in tune with the Virgin's arm. Different textures abound; they are part of the smoother neck and the leonine openness of the Virgin's face.

I will turn to the earlier Battle of the Centaurs relief. Tolnay has remarked that with difficulty one distinguishes the Centaurs from the Lapiths, the males from the females. And there is certainly no question of victors and vanquished. He even uses the adjective 'homogeneous' for this timeless panorama of struggle. 'Joined to the material that has been carved and to each other, the figures appear to be ramifications of some organic entity.' (*Michelange*, Paris 1951, p. 15.) There is, then, a sense in which the relief confronts us with a single body: we are made to realize that the articulation of the many nudes is an articulation also of the homogeneous nature of the stone. Nevertheless the nudes are in conflict, though the passionate scene of horror is threaded with an ideal oneness: a composition of diversified, very palpable objects and movement joins company with the element of non-diversity. These together encompass the formal qualities that perpetuate the tension of the subject. Thus, the rough globes of all the participants' heads contrast with their smooth bodies and allow of that diversity of texture by which we arrive at a sense of the original body. It is no surprise that similar rough blocks, scraps of the top surface of the quarried marble, are

weapons in the hands of two figures on the left, boulders for hurling; a touch that again brings homogeneity into the same orbit as conflict and difference.

Thousands of battle scenes have been executed in relief, especially in Roman times. The theme as such is not of moment, whereas the 'homogeneous' yet dire, even confused, pitting of limb against limb in Michelangelo's version, enlarges the ancient sensation of propinquity, brought to us through images inspired by texture that mediate as well between the artist and his material; for they are the *mise en scène* of the artist's formal constructions no less than of the æsthete's attentiveness.

Significant texture, of course, can rarely provide the first aim of the executed work: it is nearer a means of *rapport* with the medium and so, with art, than an end-in-itself. In view of our present-day genius for abstraction, for essence, in view of our corresponding rootlessness and iconographic poverty, we cannot expect otherwise than that many modern artists should be taken up with the quiddities alone; that æsthetes should be charmed above all else by messages sent to the workshop of æsthetic appraisal, provoking exquisite sensations of small stamina, stimulating æsthetic hunger. A proportion of the pleasure in each work is the pleasure of contact with the idea of art itself: modern art would suggest that we enjoy very close contact.[16]

The carver's stone is precious; his effects are therefore economical. Berenson has provided the best exposition in one sentence of Michelangelo's formal aims: 'A striving to pack into the least possible space the utmost possible action with the least possible change of place.'[17] Even so, the block itself will often remain recognizable.

In the Medici chapel, the huge back of the Day (Plate 18) is half-turned towards us, a defiant pose of impossible discomfort, a furrowed bulk so rippling that we align our impression with topographic experiences, with mountain contours between

cloud. The nearer arm is flung across a huge, restless girth; we see over the valleys to other ranges. However, at the same time we appreciate that those expanding planes are packed into astonishingly small room, never better than when we look at the photograph taken from behind the slab and see that this twisting bulk is backed by an emaciated, tapering block, the tight flesh, as it were, of a starving pregnant woman. (The description is more apt for the back of Evening: from this angle, Dawn and Night are the most beautiful.)

The imaginative and very skilful packing of the stone was often emulated in Baroque times but never surpassed. Although such works are meant to be viewed from the front, although their backs are false in Ruskin's parlance—indeed, much more often than not they are meaningless—I would suggest that the Allegories and the Dukes of the Medici Chapel possess backs of the utmost significance, the outcome of an imaginative relationship with the stone and therefore of 'three dimensional conception' no less valid, at the very least, than those far different conceptions for which this term is priggishly reserved at present.[18]

The unpolished roughness of Day's long head, at right angles to the fluted flat pilasters behind, brings architecture into the service of his strength (Plates 15 and 18). The narrow, deep niches with the Dukes they frame, afford a most wonderful experience of smooth-and-rough, the smoothness of ivory, the crystallizations of rock. Fluted and beaded architecture contrasts with the nude to which it is parent. Light from overhead keeps the faces in partial shadow, falls on the undulating planes of the bodies like sunbeams infused with the sea . . .

There is a temper about the David that argues the dramatic economy of the marble whose story is well known. We learn that here truly was an emaciated block of unusual length and thinness, excavated at Carrara by Agostino di Duccio for a figure to be skied on the Cathedral (where thickness was of no

consequence). He did not proceed with the work; the block was then mangled by the attempt of another artist . . .

What genius to make of this poverty the vital thinness of a hobbledehoy (Symonds' word) with huge extremities, with a troubled, resolute glance; a thin-set giant, possessor of a reserve of strength. The stone's height, the statuesque poise, dramatize the young life which is shown coursing in vein and muscle. (The more truly felt image nowadays for so firm an elasticity would be a well-sprung car, in preference to the floating ease of an untaxed torso upon the hips, or the bend of the midriff above the stomach.)[19]

The movement forward of the David's left thigh communicates both tension and pliancy. Knee and neck muscles, spaces between fingers and toes, the pubic hair, provide indispensable roughness to the composition. There is a bare elegance, perhaps Michelangelo's sole reference, entirely transformed, to the posturing which was, for him, a foreign characteristic in the Florentine art of the second half of the fifteenth century. (As the earliest drawings indicate, he sought out from the first the rectangularity of Giotto and Masaccio.) At the same time, both the Bacchus and the David exhibit the classical formula for achieving depth of planes: one knee forward, one foot back, the torso inclined gently backward, the head forward, the shoulders slightly hunched. Michelangelo's *contrapposto* is a transverse enrichment of classical pose: it demonstrates a whole figure, a whole person whom it was not easy thus to visualize intact: it corresponds to a need of emphasizing reunion within the object and within himself, or parts that have threatened to fling away their identity: each complication in the pose underlines a unifying power which has not been easily won; enhances the grip of the centre.

Although the first impression is of a tall, tapering figure, the depth of the seated Medici Madonna (Plate 13) on the line of her foot is nearly half of the figure's height, and appears to be two

thirds. The many directions, the straddled infant's turning backward, the planes below the Virgin's vast lap and above, magnify this depth, whereas her inclined head bends forward at the summit. On one side there is a closed effect arising from the projection of knees and limbs carried down by the Virgin's crossed leg: the other side is open; there are bays formed by folds, a panorama of ridges and serrations capped by the dents of the Virgin's bonnet. A common impression will be that all this substance has suffered articulation slowly far beyond the centre.

Michelangelo was probably only sixteen or seventeen, and still the guest of Lorenzo de' Medici, when he executed the Battle of Centaurs and the Virgin of the Stairs reliefs. They show already the squareness, the monumentality, the rest-lessness, the search for the union of many planes. He substituted the whole figure of the Virgin for the usual half figure. She sits on a large rectangular block cut just below the original surface. The tilt of her right foot in the foreground plane adds to the surface differentiation both in regard to rough-and-smooth and in regard to depth: the over-lap of her garment on to the block where she sits, contributes to the same effect, so too the Herculean infant's turned out arm and hand which we meet again in Day, in the seated Duke Lorenzo of the Medici chapel (Plates 14 and 18) and in copies of the Leda. This gesture exhibits unease, in terms of the muscular restlessness attributed to great strength. The sibylline Virgin has been called a virago and her repose a form of suffering. Tolnay is doubtless right to interpret the heroic sadness in this Madonna and in the one at Bruges in terms of Fate; of visions of the Passion. But we should ask ourselves why long after adolescence Michelangelo continued to enlarge upon that theme, why, in fact, viragos—though not in the sense of termagant—are the pre-dominant feminine type in his work. The beautiful face of the Madonna at Bruges may remind us of the marble David. She has needed an element of bisexuality for her role as the artist conceived it. The question concerns this kind of heroism.

Michelangelo scorned incident and *genre*. A merely pretty mother or playful child set him no target. He showed his characters as subject to a 'universal' theme of which there were plenty in the current iconography.

We turn to his last extant works of sculpture, the *Pietà* in the Duoma at Florence (Plate 23) and the Rondanini *Pietà* now in the Castello Sforza at Milan (Plate 24). With death near, at the edge of the homogeneous realm of shadow, he was at last able to join elements that had once demanded a resistant strength to accompany their merging; or that had been represented as linked but disparate forces. (There is an early drawing in the Ashmolean at Oxford of St. Anne, the Virgin and the Christ child which was probably executed in the context of Leonardo's cartoon of the subject, then on exhibition at Florence. The contrast between the tugging masses in the drawing with the Leonardo conception has often been remarked.) It would appear that between the shadow of the absolute merging into nothingness brought about by death, and the shadow of his long habit in religious as well as æsthetic expiation, Michelangelo could envisage more directly the participence of one being in another.

We have Vasari's word for it that Michelangelo himself figures as Nicodemus, the standing figure at the back of the Duomo *Pietà* (Plate 23). He supports the right arm of the dead Christ and seems to be turning the corpse even more to the side of the Virgin who has Christ's head upon her cheek. We see Michelangelo, then, that most unaccustomed figure, in the exotic paternal role (more active than is St. Joseph as a rule) of consigning the son to his mother. But nothing jars this deeply moving work[20]; deeply moving because, in a reversed form, we are able to partake, as was the artist in carving it, of an ideal reconciliation. So far from usurping the position of Nicodemus or of St. Joseph—though perhaps that too is recounted here[21]—it is he, Michelangelo, who is the son once more, the child who sought to come between the parents, who longed to restore the

father to the injured mother, to join them in harmony. But they are dead or overcome with melancholy: nevertheless, surrendering more direct uses of potency, he will stand behind them at the apex of the triangle, the puppeteer, the artist, for ever the grieving, resourceful child crying out for resurrection, forcing on the hard beauty that finally coagulates from the endless ceremonials of sadness . . .

Michelangelo's mother died when he was six. One of the mainsprings of his adult life, we have seen, was to keep his father going, and his brothers came within the orbit of the same compulsion which contributed largely to his extreme family pride. He fended for them all. Yet we will suppose that at the decisive stage of his emotional development it was also the father he wanted for himself, the mother's place. (A notably passive streak in so rebellious a character would make his attitudes unusually many-sided to his patrons, to Julius and to the Medici.) In the extraordinary Rondanini *Pietà* (Plate 24) where an upright dead Christ is supposedly supported from behind by the Madonna standing on a higher level, there is the effect, none the less, that the second figure rides on the back of the first. Michelangelo's father had been dead for thirty years: but in a sense he was not allowed to die: corpse or no corpse, emaciated by death, growing dimmer every day, he was still the family's active principle to his son who had in fact supported him.[22]

At the last, in the Rondanini *Pietà*, heroic conquest was abandoned. One of the two basic images that inspire Form is paralleled here by the underlying content of the subject-matter. Ancient grief and depression calmly occupy the field in virtue of their paraphrase of death: but Michelangelo's Saviour will redeem and carry him: at the very last there is the first love, head by head, mouth at breast, an utterly forlorn contentment that merges gradually with the undivided nature of the final sleep.

I have thought it appropriate to refer to the final 'happy' phase

at this point because it helps us to visualize one of the many alternatives of his temperament from which Michelangelo's art proceeded. A passive inclination to which he finally almost surrendered, albeit with a masculine austerity, contributed throughout his working life to the tension of his forms. A virile force was in control; for long stretches of his art, passive signifies encumberment and active, disencumberment. There is little sign, one might have said, before Michelangelo left for Rome in 1505 to work for Pope Julius, before the Laocoon came to light in January 1506, of that encumberment of his forms so evident in the Julian Slaves whose conception doubtless influenced the Sistine ceiling. Yet his journeying between encumberment and disencumberment was incessant: it will surely be agreed that no figure in the whole range of art affords so vivid an image of disencumberment as the marble David, disencumbered of clothes, of weapons other than the sling, disencumbered of the years. This nakedness, of course, belongs to the subject-matter and therefore to a thousand Davids, but Michelangelo adopted the poetic Renaissance conception with an unrivalled wholeheartedness: his still David of the turning head embodies disencumberment as never before nor since, not as a negative but as a positive state of earthy presence: disencumbered of cheers, of fame, even of the conquest which he has yet to perform. In this idealized presentation of a palpable, nerve-filled body, we encounter the classic synthesis between ancient experiences of what is undifferentiated or absolute and ancient experiences of what is particularized, a conjunction that is part and parcel of the formal elements in every art. No wonder that in Florentine eyes so attuned a David became the image of political, everyday Freedom. Athenian statuary with a similar self-possessiveness had once provided the same thought.

We are bound, then, to attribute to the weight of Michelangelo's figures of early date—to the Cascina drawings, for instance—and to the huge energy that liberates them, the

character of encumberment disenthroned: inheriting themes of naked energy, of brute strength from Pollaiuolo and Signorelli, Michelangelo transformed oppressive weight into the breadth and pumping power of the thorax especially, into muscles that renew themselves by partaking of bulk. The machine for crushing becomes the instrument for lifting, for release. Guilt, bad internal objects, are identified with the oppression of marble weight, redemption with an easing, but in a sense ever so stupendously muscular, that there are no overtones either of smugness or of romantic enthusiasm for striving *per se*. Faces are not contorted with suffering or effort; indeed, faces are of much less significance than torsos to the artist: many drawings, apart from the studies of movement, show this to be so, none more clearly than the careful design for the first carving of the Minerva Christ.[23] Thus, in the drawings especially, the human frame, rather than the features, represents the person; and often, it seems to us, the state of predicament in which Michelangelo passed his life, transubstantiated by this genius of great fortitude into an ideal condition of slow, perhaps cumbersome, disembarrassment. I have particularly in mind the four unfinished Giants (Slaves) who wrestle with their stones, with time, with eternity, in the Accademia at Florence (Plate 19).

I am suggesting that in support of Michelangelo's sense of predicament and guilt there existed a state of uneasy passivity, known to us in terms of an oppressive weight which, however frightening, had at one time been partly welcome. One of the so-called Slaves or Captives of the Louvre, perhaps the most typical of Michelangelo's surviving major works, is bound, tied. (According to the first plan of 1505 for the Julian tomb, it seems that there were to have been sixteen of these prisoners as they are named by Condivi and Vasari[24].) They are figures of passivity or suffering, and also of unusual strength. We are not made to feel that strength evaporates; though death will overcome it, the strength still shows, or, rather, the vision remains, as if coming

from profound sleep. Indeed, while phantoms possess the Captives, a nightmare of pound-by-pound oppressiveness, their raised, bull-strong bodies translate some of this dependence into the slow particles of health. The so-called Dying Captive of the Louvre is a relaxed image (Plate 12). He submits tenseless to his dream, yet sustains with the huge, refulgent orbit of his form the vigilance of light. His beauty is the one of a sea-cave's aperture that allows and withstands reverberating waves within. . . . These beautiful forms, foreign to self-pity or to sentiment, are the product of deprivation, surrender, revolt, enlisted by an idealizing yet naturalistic art.

In considering the St. Sebastian of the Last Judgment fresco (Plate 21), we first need to conjure up many Sebastians created in the previous century. As long as myth retains power, as long as the style of symbolic treatment remains approximate, art will grow swiftly from the soil of art. We cannot conceive Michelangelo's achievement except as a summit rising from the Renaissance, rising from all the creations of his period whether in a particular or in a general sense.

We have conjured up, then, a hundred fifteenth-century Sebastians, graceful, suffering, youthful, long-haired, tied to the tree. But here, on the Sistine wall, the arrows no longer impale his body: awaiting commendation he holds them in his hand. No longer tied and upright, he kneels in calm, relaxed expectancy. A tanned champion, he appears to be resting between the field events of a pitiless Olympiad. The episode of the arrows has become in our eyes an episode of training: their tips must have stimulated the giant body which has massively closed upon the wounds, which has closed, as it were, on a great deal of stimulus, shutting it in. The arrows have fertilized Sebastian: gigantic, muscular, of prodigious weight, he is yet full of spring, and somehow protected, clothed, muffled even, by his own sleek nudity, as an elephant by the wrinkled hide. The heroic proportions are so generous that we become aware that his body might

suggest the agile cushion sometimes associated with superlative strength, with the loose-knit silence, for instance, of the cattribe. Not that it is strong, this reference to the animal kingdom, in any figure by Michelangelo. On the contrary, his men and women of giant frame have a power of heroic intellect in place of the mobility of animals. If some suggestion of the leonine plays about the head of Eve in the Sistine Fall, and about the head of the Madonna Pitti (Bargello), it is a suggestion wholly subservient to the one of Amazonian strength: whereas, in contrast, the recumbent Adam of the famous Creation, fertilized by the finger of the Almighty whose gesture is authority itself (especially when compared with the more usual presentation of divine afflatus), possesses an enduring lassitude (Plate 10). The fact is that virile creatures such as he and Sebastian and superhuman: without a trace of effeminacy they incorporate the female powers. Hence the *terribilità*.

And so, on the Sistine ceiling the anomaly of the issue of Eve from Adam's side, beckoned forth by the Almighty midwife, dissolves; and we realize with awe that the keen, the sublime, God the Father of the Creation of Adam controls about him an uterine mantle filled with attendants who clamber close, souls yet to be born, attributes as yet of his own essence (Plate 10). In the History of God separating sky (or earth) from water (Plate 11), we see the attendants more deeply ensconced in the inflated cloak from which only the upper part of his body emerges with taut, cylindrical simplicity. The features are those of Adam: hair, beard and hands flame with the bisexual creative strength which we readily identify with the imaginative urgencies that have governed the artist.

But what is the final evolution of the superhuman nudes? If we turn to the late Crucifixion drawings, to one at Oxford or at Windsor, we see in each a mourning attendant whose nudity is, so to say, of a quilted substance and dimension, more proper for an Eskimo matched for encounter with a polar bear. Among our

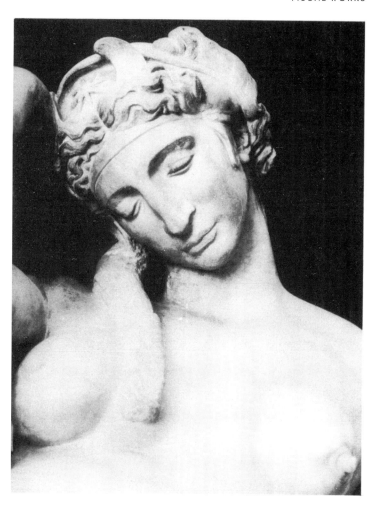

17. Head of Night

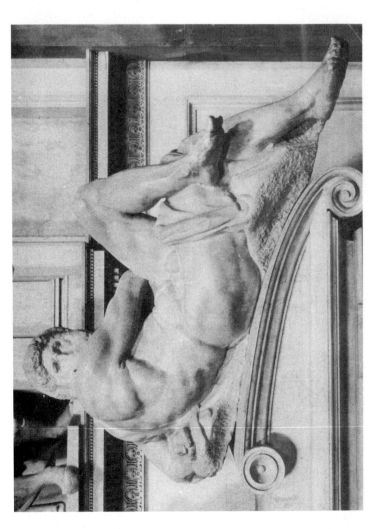

18. Day

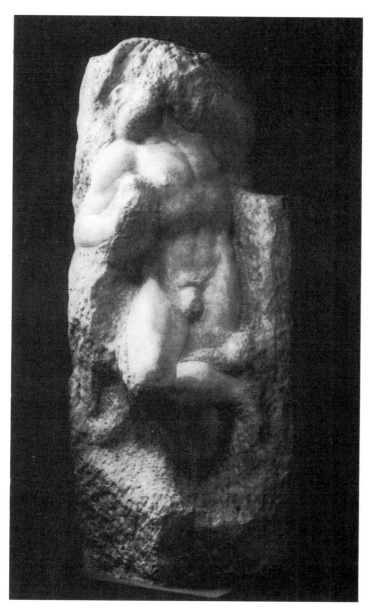

19. Unfinished Slave or Giant

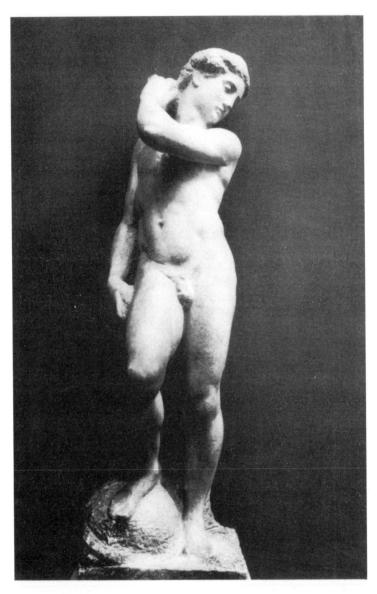

20. Apollo-David

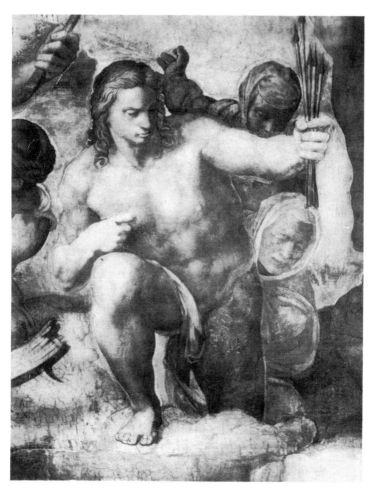

21. St. Sebastian of the Last Judgment. Fresco

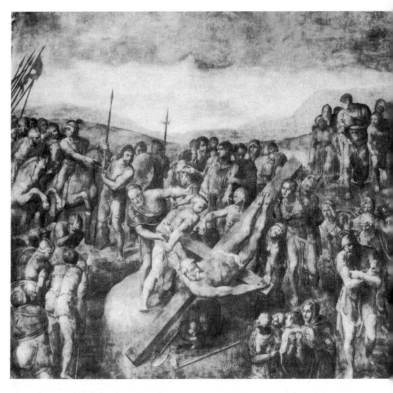

22. Crucifixion of St. Peter. Fresco

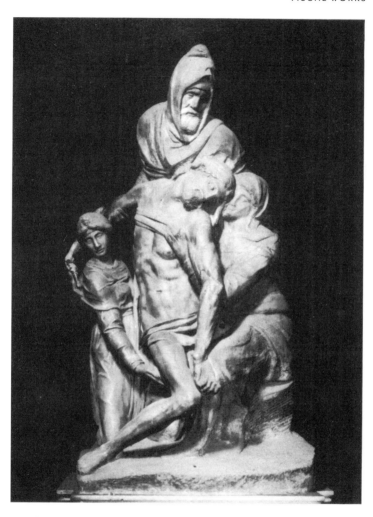

23. The Duomo Pietà

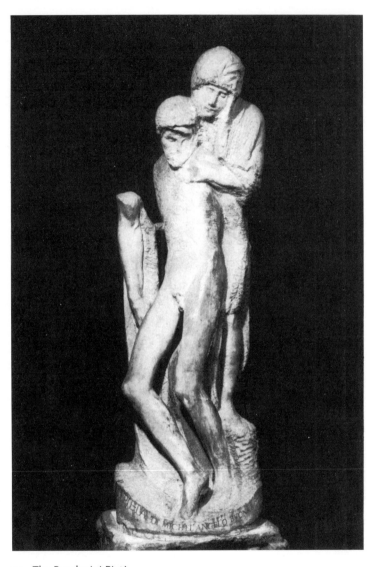

24. The Rondanini Pietà

thoughts associated with the appreciation of these superb and moving works of art, there may well be those which suggest that at the back of the long cycle of Michelangelo's heroic figures, behind the successful omnipotence (successful in art) to which no homage paid will ever seem sufficient, there lurks in corresponding strength a frightening image of the utmost brutality, an oppressive image of sheer weight that had overcome the child. So it seems, at any rate to the present writer who has been reminded of his subject by R. Money-Kyrle's account of observations by Roheim concerning the overmasculinity and underlying femininity of the men in some central Australian tribes, and concerning the emergence of that undying, infantile conception, the phallic woman.[25]

Michelangelo projected into art a heroic, constant movement that overcomes, or rather absorbs, depression and the state of being overpowered. There are many reasons why the Michelangelesque woman—she too must resist a mighty attack—needs to be indomitable, a seer, a prophetess who foreknows and overpowers evil by her own tragic scale. Whatever the ferment, she must possess the brooding calm of a fine youth, the marble brow, the generous, unsullied resignation, though she be Hecuba herself.[26] Drawings show many more ordinary possibilities, but that is the best of it, the Bruges, Pitti and St. Peter's Madonnas, the Delphic Sibyl, the Virgin of the Steps. Later in life, swayed by the rustlings of renewed religion (and, perhaps already, of Vittoria Colonna) he conceived that archetypical Baroque actress, the Virgin of the Last Judgment (Plate 1).

Night and Dawn in the Medici chapel had revealed the nature of the full depression about the woman (Plates 14–17). They are carvings that make of depression itself, rather than of the defences against it, a heroic cycle; a statuary less of uneasy grandeur than of grandeur in unease, yet figuring an anguish not unreconciled with the formula of an antique river god's

vegetative settlement. The women are inactive; there is no expressionist thrust beyond the material, nothing pointed; on the contrary, a great deal to distract us momentarily, sleep, fatigue, surfeit, a relaxed and slow awakening upon the perilous incline, fruitful images which soon broaden to an universal recognition, undisturbed by the intensity that provokes rejoinder, of profound unrest. This feeling is unescapable: it comes to us through the sense of touch and the consuming eyes, from a hundred sources that interweave, monumental composition, modelling, movement, directional contrast and the rest. It finds the hidden depressive centre in ourselves, but even did we not possess it, we should be aware that here are great works of art, here an eloquence of substances that is read by the tactile element inseparable from vision, by the wordless Braille of undimmed eyes. On the other hand, such clamant evocations of hidden depression could not reach us—our minds would be closed—were it not that they are conveyed in the reparative, reposeful terms of art. Employing the oppression of death to enhance the satisfactions of the lively senses, the artist can display an obsessive grief or cruelty which he would have needed to hide were it not thus repaired by the ideal relationships expressed in Form.

Generalizations are often symptomatic: it is the precise, the particular, the primitive hurt that consciousness must keep at distance. 'I live on my death', wrote Michelangelo. . . . 'And he who does not know how to live on anxiety and death, let him come into the fire in which I am consumed' (F. p. 31). The state of mourning in which Michelangelo spent his life is akin to death where death is conceived as the irremediable loss of what is good. The Medici chapel is a burial chapel dedicated to the Resurrection: it expresses the act of mourning and also the only answer to that condition, the re-instatement, the resurrection of the lost good person within the mourner's psyche.[27] On opposite walls the *Capitani*, idealized figures who have, as it were,

sprung to their thrones from the sarcophagi broken at the centre by the counterweights of the Allegories upon them (Plates 14 and 15), look in the direction of the marble Virgin (Plate 13), towards that separate, all-sufficient object, the mother, the original object once long ago attacked, destroyed and despaired of in the outside world. The Allegories on the tombs below are not, of course, the hired mourning figures of conventional necrology, but Times of the Day that in effect construe the loss endured throughout the twenty-four hours, figures not only of loss, but, from their very concatenation, of the restlessness, dissatisfaction and suffering that keep loss fresh, just as the impact of these figures renews itself upon us.

NOTES TO PART II

1 Wölfflin. *Classic Art*, trans. 1952. 'If any one man', wrote Wölfflin, 'may
 be held responsible for major changes in the history of culture, that
 man was Michelangelo, who brought about the generalized heroic
 style and caused place and time to be disregarded.' . . . 'The sixteenth
 century did not idealize in the sense of avoiding contact with actuality
 and seeking monumentality at the expense of clear characterization:
 its flowers grew from the old soil, but they wax bigger. Art was still a
 clarification of everyday life, but it was felt that the greater demand for
 dignity of presentation could only be satisfied by a selective choice of
 types, dress and architecture which were hardly to be found in
 actuality.'

2 *Cf.* Michelangelo's Dantesque madrigal (F. p. 205). The sense is as
 follows: Just as your image has long been engraved on my heart, now
 that I am soon to die, engrave your features on my soul. . . . Like the
 Cross against demons, it will make my soul secure. . . . On attaining
 heaven, this image should be returned to the celestial powers so that
 they may use it again on earth. (Survival of the good object after
 death.)
 The Madrigal (F. p. 200), starts: 'The more I fly from the altogether
 hateful me, the more I turn to you' (the part of me I love). Similarly,
 with the loss of the good object, the poet has no light, no salvation

(F. p. 108). In another poem of loss, Michelangelo describes himself as a piece of coal away from the kindled wood. Without the bright wood near it, the black coal consumes itself in darkness until it becomes cinders.

Such pertinent images of a good object *within* the self are common to all love poetry. The state of being in love is the flash that strongly illuminates this continuous necessity of our 'spiritual' being.

Much of Michelangelo's poetic grammar is extremely difficult to fathom. I have found invaluable C. Guasti's literal prose renderings in his pioneer's edition of the poems (Florence 1863).

3 For one variant out of a multitude in the combination between the two kinds of feeling, *cf.* this sentence of Susan Langer's (*Feeling and Form*, 1953, p. 268), 'Lyric writing is a specialized technique that constructs an impression or an idea as something experienced, in a sort of eternal present; in this way, instead of offering abstract propositions into which time and causation simply do not enter, the lyric poet creates a sense of concrete reality from which the time element has been cancelled out, leaving a Platonic sense of eternity.' In other words, there is a combination of precise things or happenings with a timeless all-inclusiveness. One parallel is with Egyptian funerary art, more or less static for 2000 years from the time of Narmer, an art, like Michelangelo's, specifically of the body to which were attributed both the present and the timeless, all-incorporating, aspects of things. Private tomb paintings suggest without mystification that ordinary, everyday activities have kinship even with the state of death; that there is no tension whatsoever between the expression of the timeless and ephemeral. Thus, a keen sense of individual life could be rendered in combination with an appearance of inorganic rigidity; individualized heads were joined to articulated yet nerveless bodies. The bare mythology of art as I conceive it, appears to have provided Egyptian culture with a predominant conception of the universe.

4 The representation of space, of course, has not as a rule depended upon perspective science that enlarges both the distinctness of the relationship between objects and the homogeneity of this medium. The styles of many cultures, however, have eschewed or contradicted this space in a desire to isolate the object, even more to bestow on the object an overriding transcendent significance.

5 The following is a very brief psycho-analytic summary of the theory of Form I have adumbrated: Emotion of every kind is presented by art in terms of objects of the senses (without the major use of projective

identification or 'concrete thinking'), under the ægis, therefore, of object-relationships (inner and outer) whose combination underlie the Form, the mode of æsthetic expression. The range of relationship with objects extends from the part-object relationship with the breast to full or genital object-relationship. We can distinguish a compound of these two extremes at any rate, in the object-relation emotions that underlie the character of Form. In view of the reparative function (here assumed) of art and in view of its admittedly regressive nature, the latter object-relationship is typified by the relationship to the whole mother of the depressive position.

The artist is, of course, reconstructing also by his art his own body, his own ego, an identity which is bound up ontogenetically with the conceptions of outside objects. But see my formulation printed in the volume already referred to, *New Directions in Psycho-Analysis*, where will be found Dr. Segal's important paper on art and depressive states.

6 The mountains of Carrara where Michelangelo spent so many months excavating marble and the roads to transport it, provide the only landscape we associate with him. Those white slopes are likely to have influenced him profoundly. They were the early scene of his command of many workers and of the stone midwifery, of the sometimes dangerous raising of roughed-out columns (M. pp. 394, 403), a barren scene, almost lunar, which he sought to master with his own austere fertility (*cf.* note 15, Part I), where, likely enough, omnipotent notions seared in the quarry were translated into an identification with the untouched peaks.

7 *Cf.* Anthony Blunt. *Artistic Theory in Italy*, 1450–1600, Oxford 1940, p. 74.

8 This power of visual memory was the fruit of an extreme susceptibility and openness to impressions. Vasari found an interesting way to emphasize it. Michelangelo could make use, says Vasari, of the work of others even though he saw it only once, and in such manner that scarcely anyone has ever noticed it; 'Nor did he ever do anything that resembled another thing by his hand, because he remembered everything that he had done.' Vasari then tells an anecdote of the young Michelangelo 'playing for supper' with other artists who competed in outlining a clumsy, puppet-like figure similar to those scrawled on walls, a thing difficult to do, says Vasari, for a man steeped in design. Michelangelo exactly remembered one of those absurdities.

This light episode or allegorical story will to-day start a train of thought concerning the extent of the appeal of a primitive form to the

greatest of artists (steeped in civilized design). Similarly, it is not so much the absurdity that interests us in Vasari's story of the Roman prince who, fancying himself as an architect, caused huge square niches to be built into his walls, with rings at the top. On being asked by the prince what ornaments should be placed there, Michelangelo answered: 'Hang bunches of eels from those rings.'

9 *Cf.* my *Stones of Rimini* (1934).

10 I have long thought that the appreciation of this element of *disclosure*, particularly in many Quattrocento low reliefs, to be indispensable for the understanding of Renaissance art. Here is an example of an unformulated motif of which the right-minded art-historian, hunting for a precise and once overt derivation of each plastic and icono-graphic theme, can take little cognizance.

No other art rivals the Renaissance, particularly the early Renais-sance, in this quality of disclosure, an effect dependent on our sense of contrasting yet supporting textures. But the direct use of this effect is common elsewhere also. Exiguous drapery, for instance, put to such fine use in the Renaissance, is a usual means in much figure art (particularly in the Antique from which the Renaissance made so many adaptations) for suggesting not only movement, but more comprehensively, the smooth-and-rough textures that vividly enhance the burnished palpability of the body.

In view of the well-known erotic appeal (in life) of the semi-nude, it appears possible that the excitement aroused by partial concealment, an excitement which suggests the hungry infant's massive impatience for the uncovering of the breast, may, in some cultures, sharpen the aesthetic awareness of texture that is rooted—so I think—in the infant's oral needs.

11 It is likely that Michelangelo expressed himself forcibly on this matter. He is made to do so in the dialogues on painting of Francis of Hol-land, a miniaturist who came from Portugal to study design in Italy. (Extracts from the MS. were translated into French and published in Paris in 1846 as part of a volume entitled *Les Arts en Portugal* by Count A. Raczynski.) Francis, who wrote his dialogues some ten years after, was present during 1538–9 at a time when Michelangelo and Vittoria Colonna used to meet with their friends in San Silvestro. The first dialogue introduces a conspiracy on the part of the company for the benefit of Francis who naturally wants to hear Michelangelo (not yet entered) on the subject of painting.

Vittoria Colonna leads the discussion into deeper waters with a

remark which would seem likely to have been well in character. 'As we are on the subject, I would very much like to know what is your opinion of Flemish painting which seems to me to possess more piety than does the Italian manner.' Michelangelo is made to answer slowly as follows: 'Flemish painting pleases the pious better than any Italian style. ... This is not due to vigour or merit in the painting but is entirely the fruit of pious sensibility. This art pleases women, especially those who are old or very young, similarly nuns, the religious and a few nobles who are deaf to real harmony. The chief aim of Flemish painting is *tromper la vue extérieure*, to represent either objects that charm or those of whom one can think no evil, such as saints and prophets: otherwise, stuffs, ruins or very green fields shaded by trees, rivers and bridges, in fact what they call landscape with plenty of figures dotted here and there. Although this appeals to some, it contains in truth neither reason nor art, no symmetry, no proportion, no taste, no grandeur. It is an art without body and vigour. Not that they don't paint even worse elsewhere. If I speak disdainfully of Flemish painting, it is not because it is entirely bad but because it aims at treating so many things with perfection when one important thing would have sufficed. The result is that none of these things is presented in a satisfying manner. ... Good painting is noble *in itself*. ... It is nothing else but a copy of God's perfection, a shadow of his brush, a music, a melody.'

In the second and third dialogues, Michelangelo uses the word 'design' and 'painting' as interchangeable. Painting in this sense, he says, is at the back of every kind of manual skill, 'in every movement and action'. All they left behind shows us that design was the basis of Roman civilization, as useful in war as in peace. The trained artist can turn his hand to any craft or science, and quickly outstrip the accustomed practitioners ...

(I do not know whether readers will have momentarily felt as I have done in translating these sentiments attributed to Michelangelo. Here is the programme, the manifesto, of Italian Renaissance art: so vivid a programme may cause some difficulty in believing that it was in fact achieved, that sculptures, paintings, defence works, drawings, buildings, poems of Michelangelo exist; since we have been battered in the last thirty years by æsthetic manifestos.)

Disegno, then, is the basis of engineering: the force of *disegno* gives proof of *rapport* on the part of the artist with the structure of organisms designed by God. ... It is implied in the dialogues, particularly in

the criticism of Flemish art, that the human body must be the prime vehicle for the learning and for the exercise of *disegno*. The study of the human body equips the artist for engineering by means of an architecture founded upon human form.

The relationship of painting with sculpture is discussed in the dialogues. Michelangelo's authentic views (tempered with ironic fulsomeness?) on this matter are stated in a letter to Varchi (M. p. 522). 'I affirm that painting is the better the more it tends towards relief, and relief is the worse the more it tends towards painting. However, it has been my custom to think sculpture was a lantern to painting, and that between them there was the difference of the light from the sun and the light from the moon. But now that I have read your essay where you say in philosophical language that things which have the same end, are the same thing. I have changed my opinion. And I say now that what requires more discretion, what is more difficult, what contains more obstacles, does not necessarily result in greater value. If that is so, then no painter should despise sculpture nor the sculptor painting. I mean by sculpting, the art of taking away material, while the art of adding to or putting on, belongs to painting.'

12 An identification with the body is, of course, employed in architecture to procure effects of transcendence. The measure of mass, of organization, of gleaming stability, is ourselves. In terms of wall and aperture, of projection and recession, architecture records the sensitiveness of our breathing organism whose life, physical and mental, is a taking in and a putting out (*cf.* my *Smooth and Rough*, 1951). But this transcendent replica of our condition, would not be greatly significant were it not that in the very same terms of the body we were offered by architectural effect the pleasurable versions of those fundamental attitudes to the outside world which I have already described in connection with the dichotomy of space, combining a transcendent, all-inclusive element with the element of notable particularity.

It may be thought paradoxical that I refer to Michelangelo's own architecture in no more than a few sentences. In spite of much invention, in spite of the magnificent beauty of his Capitol design (*cf.* Stefano du Perac's engraving of 1569, reproduced in *Michelangelo Architetto*, A. Schiavo, 1949), in spite of the interrelation of smooth and rough surfaces, particularly in the Laurentian library, vestibule and staircase, his architecture remains indeterminate for me, in the sense that it contains but the residues of his style. Stripped by architecture to abstraction, a history, an evolution of feeling, apparent in

the sculpture and painting, disappears: we are left, abruptly as it were, with an euphoria and a grandeur not always happily combined with their agitation, in a manner that was to become far more convincing in the Baroque age that Michelangelo initiated. Nevertheless this Baroque element (as opposed to the Mannerist affiliations of the Laurentian library) must be connected also with Michelangelo's sculptural *non-finito* (see Note 15). His architecture shows that *non-finito* is the medium not only of synthesis but of a scattering or disruptive force that will lend itself to effects that mirror those of flood-water or of lightning. The flood force met opposite currents that also derive from Michelangelo, the power of classical pomp: hence the Baroque joinery of broken massiveness, the rushing together, the tearing apart, basic movements that provided a theme of extraordinary contrapuntal development in all the arts.

13 *Cf.* my *Smooth and Rough* (1951).

14 This was in harmony with the Aristotelian conception of potentiality in the object (*cf.* Varchi's commentary, 1546, on the sonnet), and also with Neoplatonist tenets (Plotinus).

A less modest view of art is to be found in a madrigal and a sonnet (F. pp. 152 and 194). Michelangelo refers to the physical durability, at least, of his work which will survive long after sitter and artist (the works of Nature) have passed away. *Onde dall'arte è vinta la natura*: 'Thus Nature is overcome by Art.' Elsewhere he speaks of the uncut stone and the blank paper as vehicles to be used as one wishes (e.g. F. p. 111). Indeed, from the point of view of Michelangelo's latter-day æsthetic ideas, the attribution in the sonnet, F. p. 89, of Form to the stone, may be partly a poetic projection on to the stone of his belief in beauty as a divine image implanted in the mind: whereas the Quattrocento thinkers had felt that beauty was the underlying coherence belonging to the nature of things. But we have seen (and we shall see again) that for the most part Michelangelo was not without the earlier trust in the virtues of the object *per se*. His achievement is based upon the Quattrocento achievement.

Whereas this sonnet (F. p. 89) in honour of Vittoria Colonna is intended to express aspiration towards the Neoplatonic Idea of goodness, it is also a statement, at what commentators call the superficial level, of the deep difficulties in accommodating the power for good of the beloved with her power for dispensing misery and death.

Other poems too indicate how close are the activities of love and art for Michelangelo. This connection is apt: for, every lover feels at

one with more than his sweetheart; both are elemental in his eyes, of universal stuff. No less vehemently he experiences the uniqueness of the beloved, the acme of otherness, the essence of not-self: hence the possibility of barter, of imaginative interchange; hence, more generally, the Wordsworthian object for contemplation, primrose or peasant, a point of singularity, an unique situation, that prompted the poet's sentiments of pantheism: hence, as I have tried to indicate, the qualities in art, both static and dynamic, that underpin each formal and stylistic conception, echoing adult love, precipitating, as does adult love, far older relationships with the outer world.

J. Jacobs (*The Listener*, April 1st 1954) records that Robert Frost has said of his poem *Stopping by Woods on a Snowy Evening*, a description of a particular scene (the gradual uniform canopy of snow) which the poet has rounded off by a single-rhyme verse impounding the previous happenings and a new activity within the all-absorbing layers of sleep: 'That poem contains all I know.'

> Whose woods these are I think I know,
> His house is in the village though;
> He will not see me stopping here
> To watch his woods fill up with snow.
>
> My little horse must think it queer
> To stop without a farmhouse near
> Between the woods and frozen lake
> The darkest evening of the year.
>
> He gives his harness bells a shake
> To ask if there is some mistake.
> The only other sound's the sweep
> Of easy wind and downy flake.
>
> The woods are lovely, dark and deep,
> But I have promises to keep
> And miles to go before I sleep
> And miles to go before I sleep.
> From *Collected Poems of Robert Frost* (Cape).

15 There are, of course, differing qualities in Michelangelo's use of lack of finish (*non-finito*). St. Matthew and the Slaves or Giants of the Accademia were discontinued at a time when they had (and have) the effects of entities no less broken than are their stones, yet of entities

that are at the same time unbreakable (Plate 19); whereas the Apollo of the Bargello is a delicate instrument on which the air plays: *non-finito* contributes to this music a figured base (Plate 20). Would anyone wish that Michelangelo had gone on with the Apollo's hands, the one jointed to his side as if it were a tool that polishes, the other to the strong neck? Even more than articulation of the feet, fingers would have broken the singleness of pose. The slow ecstatic look of the face would not have survived a burnished angularity; we do not require to see all the torsion of the back, as would be visible were the straight slab of the matrix cut away on the spine.

16 Our iconographic lack to-day (see Appendix I), or impoverishment, contributes heavily, I think, to the loss of the beautifying element in art, owing to the absence of poetic systems in symbolic expression. Beauty in the narrow sense, of course, is by no means essential to the work of art; without much iconographic interposition, symbols are the more personal, more direct, more lively. But we should realize that this directness is neither a better nor a worse method *ipso facto* for attaining the sense of merging and the sense of particularity which underlie the creation of Form: and whereas the range of expression may seem the wider in modern art for being more 'free', the absence of a strong convention of the beautiful may tend to narrow rather than to enlarge the possibilities of Form, since the lesser kind of beauty has served as a step more often than as a hindrance, to the larger kind of beauty.

Works of art epitomize self-containment, offering to the senses well-organized objects that are singular vessels of emotion: yet only in some humanist art—a minute segment of the world's production—do we encounter so strong an emphasis upon corporeality as to elicit from the undifferentiated component that also inspires Form, a tempered idealism, a health attributed to man which has at time accompanied without falsity the use of an unique naturalism. Art is, of course, on surer ground in cultures that do not seek to exalt man's rationality or command (albeit within a religious setting), that serve a totalitarian conception of Fate, good, devil, the future life, Pharaoh, rite, or it may be death, the spirits of the departed. For here is the homeground of art whose paramount role, on the formal side, is to furnish a feeding from universal principles: the spectator absorbs them through the physical object: even change, ceaseless metamorphosis, becomes static, absorbable when thus identified. Of all art we become the sucklings, viewers of an architecture whose alleys have

been crowded with experience: in this ideal light we can see the chaotic as chaotic and as peace.

It is safer, then, with a better insurance against banality and prostitution, to carve in the Polynesian manner, best of all to be subject to a constraining fiat. There is not the slightest doubt that anti-humanist art which possesses so fine a grip upon the dynamic, non-differentiated element at the back of Form, is likely to ensure a longer run of acceptable artifacts, innocent of the humanist euphoria, in closer touch with the less differentiated, that is to say, unconscious, motivations; possessing even a better grasp of reality, in the sense that the child is nearer to inner reality than the adult. Stylization, simplification, distortion are needed for the processes of art. But beyond a certain point they are apt to be employed at the expense of conveying a notable otherness (something over against ourselves) in the figures or scenes represented, though the artefact is itself a model of self-sufficiency. Humanist art re-embodies the otherness of objects, rejoices in articulation of actuality at the expense, very often, of depth of feeling, at any rate after religion and iconographic systems have lapsed. Yet, shocked as we must be with the banalities of our academic art, however loudly we protest freedom, we recognize (though it may not be admitted) that some kind of realism is still the point of departure in the West, and that this norm will remain, not in virtue of longevity nor of naturalism, but because the great humanist periods discovered the only profound employment for *both* the qualities that underlie formal creation. In the work of Michelangelo, a man's predicament, conflict, are not only explored but embodied by means of the 'rational' nude in rivalry, as it were, with the precise actuality, separateness, solidity, of another human being or of ourselves. (The whole *œuvre* of Surrealist art reveals nothing in comparison.) Viewed from the angle of art and culture as a whole, the daring sanity of the Western Masters can be compared only with our corresponding science.

One of the original aims of André Malraux' book (*The Psychology of Art*, trans. London 1949) was the justification of contemporary anti-humanist art. (There are, naturally, all degrees between what is humanist and what is anti-humanist.) But Malraux is a humanist. 'Every period of retrogression is linked up with a return to the domination of bloodshed, sex and death, to a world of the diabolic and numinous. . . . ' 'Styles pertaining to happiness are among the least striking; but the more art is concerned with all that transcends man—

with the diabolic or sacred—the less man enters into its portrayals. Thus Polynesians mask with the symmetrical lines of an elaborate tattoo, the ineluctable disintegration of the faces of the dead.'

Not all contemporary art is occupied with transcendence (often equated with disintegration). Better schools affirm almost exclusively the otherness of the object. We lack—we must lack—the equality of each term that promises fullness in their blending.

17 B. Berenson, *The Drawings of the Florentine Painters*, 2nd ed. Chicago, 1938. All students of Michelangelo should record their huge debt to Berenson's most evocative scholarship. In the first edition of his book towards the turn of the century, he brought order to Michelangelo studies by classifying many hundreds of drawings scattered throughout Europe, all of them at that time attributed equally to the master. Before the days of easy reproduction (and easy access), such a work entailed an inspired feat of memory, more especially in the case of drawings wherein the smaller characteristics are often the most revealing aspects for comparison.

18 J. G. Phillips (*Michelangelo: A New Approach to his Genius, Metropolitan Museum of Art Bulletin*, 1942) has pointed out the uses of casts in revealing sections of the sculptures that are hidden in their settings. Thus, it is gratifying to find that the Bruges Madonna sits on a pile of rough stones that contrast brilliantly with the texture of her back.

19 But there remains classical ballet, sole inheritor in our time of Renaissance art.

20 The group was mutilated by Michelangelo himself, restored and continued by his pupil, Tiberio Calcagni. The Magdalen must be almost entirely his work.

21 A suggestion of overpowering Bacchanalian frenzy, derived from Antique art, has often richly contributed, particularly since Renaissance times, to the manic component in Form.

Nicodemus' head, perhaps the most moving detail in all Michelangelo's sculpture, completes a *figura serpentinata* (spiral shape of a moving serpent: note especially the frontal peak of the hood in defiance of the head's inclination), surely his dramatization, conventionalized by the Mannerists, of a yearning for phallic omnipotence. This group is by far the most weighty example.

The phrase '*figura piramidale serpentinata*' is used by Lomazzo in his *Trattato de la Pittura* (1584) where the author describes alleged advice given by Michelangelo to one, Marco da Siena. 'The maximum

grace and lightness of a figure lies in movement of the sort that painters call 'abandon' (*furia*). This movement is typified by a flame, the element which, according to Aristotle and all the philosophers, is the most active: the shape of a flame is better adapted to movement than any other; for, it has a cone and a point with which it seems to want to pierce the air, to ascend to its sphere (the heavens). So, when a figure has this form, it will be most beautiful.'

22 The sculpture is not only unfinished; an unattached arm draws attention to an earlier version on which the later version is superimposed. Michelangelo altered the group to the effect I have underlined in the last year, perhaps in the last weeks, of his life.

Condivi says that Michelangelo's father died rather from failure of will than from disease, so strong was he; and that Michelangelo used to tell how Ludovico kept his colour after death so that he seemed merely to sleep.

23 This pen drawing of the Ford collection, London, showing a careful study for the middle of the body and the faintly sketched arm and head, prefigured the division of labour in the execution of the second marble figure. For it would seem that Michelangelo made over the execution of many less central parts in the first place to his assistant, Pietro Urbano (Tolnay II, p. 89).

Vasari states that Michelangelo drew a half-length, life-size portrait of Cavalieri, his young Roman friend, but that otherwise he abhorred portraiture. This may well not be exactly true: for instance, there are possible references to a portrait bust or painting of Vittoria Colonna in one or two poems (F. pp. 152 and 194), but it does seem likely that Michelangelo did not care to confine his work to a study of individuality. The heads of the *Duchi* and of Brutus (Bargello) are by no means portraits. In contrast with Imperial Roman statuary, Michelangelo tended to particularize the body, while the head, though there be no other to class with it, has the suggestion of a type.

When his friend Luigi del Riccio besought him to design a tomb for his nephew Cecchino de' Bracci, whom they both loved, Michelangelo was in no hurry, although he had once made a drawing of Cecchino (Steinmann, *Michelangelo e Luigi del Riccio*, Florence 1932, p. 39). He was glad to exercise himself writing forty-eight epitaphs for the boy and a sonnet to Luigi (F. p. 67) in which he suggests that since art cannot furnish Cecchino's portrait when he is dead, it would be better to sculpt him (Luigi), as the beloved lives on in the lover. But finally a sepulchre was erected in S.M. Aracoeli (where it is to-day) with an

extremely dim bust of Cecchino (of no appeal whatsoever) executed by Michelangelo's faithful henchman, Urbino.

Duke Cosimo was wanting to sit for his head in 1544. Michelangelo wrote to his nephew (M. p. 173) saying that he had excused himself and that he had too much to do: moreover, there was his age and he couldn't see light.

24 The bound prisoners were to stand in front of herms or terminal figures. It is noticeable that in the monument finally executed for San Pietro in Vincoli (St. Peter of the Chains), the arms of these herms themselves are crossed and closely imprisoned by their own bandages of drapery.

25 *Cf. R. Money-Kyrle. Superstition and Society*, London 1939.

26 *Cf.* the first line of the madrigal, addressed to Vittoria Colonna, F. p. 229: *Un uomo in una donna, anzi uno dio.* 'A man in a woman, a god in truth, speaks through her mouth.'

Too much could easily be made of the fact that Michelangelo was in the habit of using drawings of male models for female figures, sometimes so evident, even in the final version. It is generally agreed that a youth must have sat for the Madonna of the Doni Holy Family (Uffizi). The torso and left thigh drawing (Wilde 48 *verso*), thought to be a study for the Leda painting, betrays no feminine characteristic, nor do the drawings for the Libyan Sibyl in Oxford and New York, Tolnay has remarked (III, 108). Masculinity is even more surprising in the rapid sketch in the British Museum (Wilde 56) for the Venus and Cupid cartoon (Naples) from which Pontormo executed a painting (Uffizi).

Wilde (p. 84) points out in reference to the male models of preliminary sketches that a sculptor 'is particularly concerned with the effect of the muscles on the surface modelling'. This would seem especially true in the case of the kind of physique in which Michelangelo delighted.

27 E. Tietze-Conrat in *The Art Bulletin* (September 1954) suggests that the initial programme for the sculpture including, of course, the Times of Day, was based upon the theme of general, corporeal resurrection, a theme chosen by Cardinal Giulio de' Medici, later Pope Clement VII.

Part III

The Poems

THE POEMS

It will be objected that whereas it is hard to embrace the conscious motives of our friends, harder the characters of those with whom we are not acquainted, it is surely monstrous to attribute *unconscious* thoughts to a historical figure with small reference to what may be known of him from others or to the sayings about himself in poems and letters.

Certainly we need to discover all we can about an artist since, by and large, the perennial fascination of the life corresponds to a need arising out of closer æsthetic appraisal. The truism, however, must be insisted upon that neither the life nor the work of art would attract us were they not entirely based on foundations formed with materials that are identical with those we ourselves have used. Of the two constructions the work of art is the more simple, the more primitive, whatever the adopted style and æsthetic convention. In regard to Michelangelo, a paradox emerges for the present writer: he feels that his comments spring from psychological theory no more than from prolonged æsthetic sensation; he considers himself on surer ground when

speaking in a general way of the hidden motivations in Michelangelo's art, to some degree shared by us all, than when grappling with the limitless complications of personality, or when judging behaviour subject to a thousand and one circumstances many of them entirely unknown, many of them strange to us; in spite of the fact that help is here at hand from eminent scholars who have long taken possession of a hoard of evidence which is probably more voluminous than in the case of any other visual artist except in our own time or in the recent past.

But the language of shape is older than the culture of personality. Art is ever founded upon the psychical tensions attaching to sensations, already at their height, it is plain, in early infancy when ungovernable fantasies tyrannize a most limited universe. The artist turns less far from them than do others. The handling of a material may not reflect an attitude of personality; but in figure art especially, it does allow of a sublimation for repetitive fantasies that were associated with physical and, indeed, corporeal, form from the earliest times; as well as for many veneers of meaning accumulated upon a shape, the artist must forge a version for this sparse dynamic frame. We read with astonishment of the seven-year-old, almost destitute boy, Schliemann, who decided at this age to discover Troy: he eventually did so after fighting his way for some forty years. Had he been a sculptor of equal genius with Michelangelo, though it is unlikely that he would then have wanted to discover Troy, we might have seen or, rather, felt through our eyes, in some work of his, Schliemann's hand, a summary of the dominant power in so extraordinary a history, the warm meaning of which, except by analogy, is hidden from us.

With Michelangelo, unwittingly, it is true, to instruct us through æsthetic sensation, a nexus of the fantasies around which his genius was wrapped, seems near to the searcher, since he was so markedly individual an artist, a defenceless giant of our civilization. It is otherwise for his circumstances, culture,

æsthetic heritage without whose felicitous turn and without their surviving relation with our own culture, that energy would not be conveyed to us in a comparable degree: such life-giving constructions form a vast metropolis difficult even to survey.

But let us seek out again the purlieus of Quattrocento art and culture from which Michelangelo drew life. We could now stipulate, *a priori*, as it were, that at the time of the great art of the Renaissance, culture in the widest sense bestowed on a whole variety of studies an uncommon union between what are more often opposing tendencies (harmonized, if harmonized at all, by the humanist artist alone), between deft observation and transcendental thought, between the exaltation of man and the hope of heaven, between flesh and soul, between health or normality and the magical, mystical, totalitarian propensities of mankind in the face of aggression, age, death, disease and disappointment. We have asserted that art always reconciles a not dissimilar antithesis; that some such union provides the essence of æsthetic value. But we cannot neglect the importance of philosophical rationalizations, along with many others, since they endorse or influence a period's æsthetic constructions, in an indirect, or, more probably, in a direct manner.

Now, Neoplatonism and any kind of thinking that, in effect, exalted Love, Beauty and the freedom of man's creative power, undoubtedly assisted æsthetic achievement. In *Neoplatonism of the Italian Renaissance*, N. A. Robb remarks that this particular doctrine could have been used just as well as a plea for asceticism: the author instances Girolomo Benivieni who, after conversion by Savonarola, collected his youthful love poems and published them with a commentary that interpreted the same imagery in a purely religious sense. But, on the whole, the Neoplatonists, moderate in the use of logic, without employing pantheism, tried to do away with, or to mitigate, medieval opposition between Creator and created: on the one hand there are the urgent objects of the senses regarded in an optimistic manner,

on the other the ideas or eternal models which justify the positive aspects of earthly things. Coluccio Salutati, one of the earliest Platonists, held, according to Robb, that God abides apart from the world in his own simple perfection and yet is present to the whole creation as an operative force. It is easy to see that since this kind of thinking, how be it illogically, avoided, except in extreme cases, a pantheistic or truly stern and other-worldly outcome, since it idealized, though well within the Christian framework, a sanguine attachment to sensuous experience—it is easy to see that such rationalizations could be of service in furthering art: Renaissance art is unimaginable without this glowing philosophical bent of many patrons. (Michelangelo himself, it must be remembered, passed some years as a youth in the house of Lorenzo de' Medici among his Neoplatonic circle.) For one thing, a temper of transcendence or ideality in combination with a firm attachment to the senses, made a bridge to the Antique world as then regarded, to Antique art; provided a spur to the enlargement of those monumental aims which we consider to be typically Italian, whereby mere naturalism and the representation of anecdote are surpassed or transcended. Again, far more generally, we discern in these doctrines, a rationalization of the dual passions fused by art, the love for the 'sensible' self-sufficient world combined with an extreme love for an all-embracing unity conveyed thereby to the senses; the *doppia Venere*, to re-apply a phrase of Michelangelo's.

But although visual art has not been so happily incited by culture in any other period of modern history, the effect was less ideal in regard to Italian love poems. The 'supernal' aspect of love was for the most part at the service of courtly trifling: the poet's concern with his medium, with the concise welter of his words, with urgent sensuous experience, was not vital enough to balance the load of conventional mysticism; whereas, in visual art, the immediate spur to the æsthetic rendering of sensation

was as acute, or more acute, than the desire to discover wider connections therein.

In spite of the humanist revolution, Italian lyric poetry remained the close inheritor of Provençal song and the *Stil Nuovo*: the main subject, as ever, was the prostrations before a (finally) inaccessible mother-figure, the courtly Christian love. Indeed, a case exists for asserting that Michelangelo's verse is a rough exercise in Petrarchan image and antithesis, a Neoplatonic elaboration of certain moods in Dante of whose work he was a notable student. It is undeniable that phrases as well as attitudes echo Petrarch or Dante; that some of the poems, more usually parts of them, exhibit the artificiality of poesy-making. On the other hand, few will deny that the cultural *moeurs* of those centuries, as well as the lyric imagery then prevalent, the conventional antithesis, even some exaggerated conceits, suited the expression of Michelangelo's temperament so well, that we are acutely aware of his authentic voice in some laborious *fioriture* no less than in simple outbursts and sardonic burlesques, in fragments unprepared for other eyes. We are justified, I think, in abstracting the more laboured poems also—there are sometimes many versions—and the tenor of their imagery which reappears again and again, out of the literary-historical context, so as to consider them solely as prime reflectors of Michelangelo's temperament. More often than of their artificiality, the reader is conscious of great pressure, great sincerity, a violence, an unexpectedness in the use of worn-out convention.

Then again, I am not aware of tendentiousness in finding that the poems' imagery endorses the previous analysis of Michelangelo as sculptor and painter. That has been the sequence: hence the short references to the verses that follow. I must ask the reader to believe that no major conclusion of this study as a whole was ever based upon evidence abstracted from the poems, for many years unopened. As in the case of the life, it

is the study of the visual art which emboldens me to interpret some patent aspects of material in the poetry.

Since the sensuousness was so nearly matched by an ascetic renouncing and religious trend, we must rejoice that Neoplatonism held the reins of Michelangelo's poetry, driving these horses along the road of the sonnet. 'His passion is rooted in an eternal paradox', wrote Robb: 'Visible things must be loved since they alone can recall the vision of pure beauty, but to see that vision and try to reveal it to men is to know that matter is forever at enmity with the spirit.' (Visible things must be loved not for any reason of theory, but because, as Michelangelo says over and over again in the sonnets, he is so enormously susceptible. Neither philosophic thought nor religious speculation in which Michelangelo was an amateur, could resolve the paradox; only art for which it can serve as the prime subject.)

Feeling to the full the pressure of death and decay, since he never renounced the nude, Michelangelo's æsthetic problem was more acute than the one of a Nature lover, of an artist equally religious yet nearer to the natural scene, who has escaped this far. Michelangelo's poems abound in expedients whereby the value of corporeal beauty should be preserved in transcendental form; and the same with love. The love of beauty, which, he says, was the endowment of his birth, appears at times to be synonymous with love *in excelsis*. There are almost no references in his poems (nor, of course, in his visual works) to tenderness. Love and beauty are incandescent entities with the coolly burning grip of radium: poem after poem speaks of the fire of love which consumes and destroys or, at best, purifies him of waste: and the poems themselves seem to burn with a cold incandescent ardour. In the sonnet numbered 55 in Carl Frey's edition (p. 42), we discover that the fire of beauty is more extensive than the love it may kindle: 'If I am not burnt up nor die because of your beauty, it is only because I perceive but a part of it.' Beauty is like the sun that inflames the world while remaining

temperate itself (F. p. 127): and he, Michelangelo, would be like the eagle who looks at a small part of the sun (F. p. 94). As well as serving in art as the instrument of reparation, beauty, it seems, or, rather, in this case, a terrifying content that lurks at the back of it (based originally on his own anal-sadistic aggressiveness), provides an instrument for scorching the guilty. Even the stone, we read in F. p. 190, has an internal fire which, if struck, may reduce it to lime so that in this way it can live for ever as a mortar which joins other stones; similarly the passion of love burns up his cold heart which, thus tempered or cleansed, will have become material worthy of the beloved.

The fierceness in this method of joining with another or in the merging with a whole, suggests the existence of a persecutory component, just as the early situation which incited the images of good objects was itself surrounded by thwarting situations, the provokers, therefore, not only of love but of hate, retaliation, guilt and the feeling of persecution. Death may lurk at the back of beauty: at any moment the good turns into the bad. Perfection itself signifies death (F. p. 157). . . . Projecting what is good without the stultification caused by mere denial of what is bad, the artist not only discovers a complex beauty that may include the bad, not only employs aggression in attack upon the medium for his constructive, reparative, purpose, he also plots so that the finality of decease to which instinct, the source of our aggression, commands us, shall lend the character of irreversibility to utterance.

But it may well be beyond the artist's power to achieve in actual situations, a tithe of the stability invented for their æsthetic counterparts. The most common subject with which Michelangelo could make a poem would appear to have been his own anxiety in connection with the loved body. The burden of it all seems to be that he takes a hammering from physical beauty (in the poems from faces, always, faces, not bodies), a hammering so severe that it burns him up, purifies him in order that he

may actively enjoy, it is hoped, eternal love and beauty. We cannot but acknowledge once more in these fiery, austere terms, so fierce yet so masochistic, the welding of active and passive components already attributed to his superhuman figures. But in the sonnets the passive element is paramount at the expense of any exertion to influence the beloved.[1] In Frey, p. 228, he is the rude model with which Vittoria makes a more acceptable image, taking away what is superfluous, filling in the gaps, moulding him with the strength of her love and interest, into better shape. In F. p. 106 we encounter a related imagery; since Vittoria has meanwhile died, the fashioning of his soul has been left incomplete. In a sonnet (F. p. 55) which displays an unusual sensuous fervour, the demand to be the shoes on which the beloved walks in bad weather, need not be remarked, nor the less fanciful passivity which dominates some of the final religious poems. (It is the coin, even to-day, of poetic piety.) In F. p. 232, for instance, God is asked to send down light (perhaps the Holy Spirit) on His fair bride (the soul, perhaps the Church), so that in old age Michelangelo's heart should be warm and comforted. He complains in the same sonnet of an icy curtain between his heart and the heavenly fire of love. In F. p. 239 he says there is nothing viler than he himself would be without God. Without the divine fire—and this we may identify with his own creative gift—he felt not only object, wicked and depressed, but also, as a corollary, it would seem, cold, frigid, though incessantly inflamed by physical beauty. 'Love made me a perceptive eye, and you he made light', he says in F. p. 97. On the other hand, in F. p. 130 he describes himself as his own counterfeit, wrapped in a darkness that serves best to define the loved one's brightness. There are four sonnets to explore darkness and the night. Illumination is then the enemy; and so vulnerable is night that even a glow-worm can do her violence. The image recalls the predicament of Night in the Medici chapel who holds a firestone in her right hand[2] (cf. Appendix II); it recalls the imagined power

of the infant as he first visualized such predicament issuing from his direct attacks, or from those he delegated. Night is scorned in this sonnet for such excessive vulnerability; in F. p. 82 she is praised for the gifts of sleep, of good dreams, of peace near to death.[3]

Whereas despair hides in the curtains of this peace, we are perhaps justified in ascribing to a line of F. p. 207, variation II, F. p. 463, that same precise confidence in a reparative act which may be discovered in connection with the Leda (cf. Appendix II); *Per vagina di fuor veggio'l coltello*, the sheath tells of the shining blade within (physical beauty tells of heavenly beauty). We would attribute to this image a reversal of that central gloom connected with the sheath rent by the punitive blade.[4] . . .

In general, one has an impression from the sonnets that the poet harbours with anxious concern, with despair, with the need for constant renewal, with a fire, violence and susceptibility persisting into old age, the beloved, the good inner object, in whose reflected light alone he can live, as does the moon by the light of the sun (F. p. 128). Now, an image of the lover living in the terms of the beloved provided a common conceit to Renaissance poets. But we may well feel convinced in Michelangelo's case, as in the case no less of some Elizabethan poetry, that the indispensable, unconscious fantasy which mastered the infantile depression from time to time, was not far different from this same 'conceit'. Love and beauty, we have noted, were almost identical for Michelangelo, who, by projecting the beloved image, sought to rescue and to immortalize the physical world as well. This beauty, then, attributed by art to a projected image in relationship with the self, will partake of the attitudes, active and passive, which he has experienced in his dealings with the loved object within; and it will assume the dangers of the bad by which (in life) the good object is beset. Thus, the Giants of the Accademia emerge slowly yet irresistibly from the stone, retarded by the night from which their heroism disentangles them.

A study of the madrigals, fragments and other pieces confirms the prevailing impression from the sonnets. The beloved is merely a power over the poet in virtue of an unspecified beauty of face or eyes: there are neither personal details nor a glimpse of satisfaction in love. We are assured repeatedly that the poet was made for this burning and for sorrow: and although he as often represents the unsupportable torture of unrequited love—a freezing and a burning together—yet he plainly says at other times that he feeds, however scrappily, upon that indifference. Nature does well, he says, in the tones of Petrarch (madrigal, F. p. 60), to unite such beauty with such cruelty, since one opposite is tempered by the other; and so, a little of the sweetness of your face serves to moderate my suffering, which, thus made lighter, renders me happy. . . . He emphasizes that he cannot surrender the suffering. But in madrigal, F. p. 173, of which there are three versions in Michelangelo's hand, he says he is in two parts, attached to heaven and to the beloved below. The division causes him to freeze and burn. He then suggests that whatever the dangers of undivided love on earth, he would then at least be one with himself. This is very unusual, since he generally seeks unity from the celestial love alone, at the same time finding reasons why the terrestrial love has some justification, even when viewed with the eyes of eternity.

An intense ambivalence causes the juxtaposition of heat with cold, of passion with frigidity. It is obvious that Michelangelo learned to distrust a situation where love could be requited; a situation that led to self-division. He says in madrigal, F. p. 187, that it would be more helpful were the beloved less gracious: an alliance of such beauty with such compassion blinds the beholder like the sun. In an incomplete sonnet, F. p. 109, we read of the eagle who not only has the power to look into the face of the sun (the beloved), without hurt, but can soar up to that height—a far superior satisfaction than the one of mere looking—from where the poet, did he attempt it, would

inevitably fall to his ruin.[5] Madrigal, F. p. 225, is more specific: satiety precludes hope: he who never loses in a game is little implicated. Then follows a weak apology for the defeatist's choice: if the beloved were to give everything, it would not satisfy the infinity of desire. . . . The madrigal on page 186 of Frey reveals the truth. He asks the beloved for a little favour but not too much: what helps another man, only annoys him: many prefer to have humble fortune. . . . (In this context and in many others we are made aware that for Michelangelo death is the other face of intimacy, just as in art, what is homogeneous or what is complete is the other face of the sensible object, the individual pattern.)

The madrigal addressed to his great friend, Luigi del Riccio (F. p. 174) speaks of the slavery he endures as the result of kindness: a form of robbery, he says. One is reminded of the sonnet, probably addressed to another benefactor, Vittoria Colonna (F. p. 95), in which he argues without offence that thanklessness is the humble and therefore polite return for beneficence. Even great beauty is like a killing weight (madrigal, F. p. 176)—we note especially the metaphor of weight in view of what has been said above—which, when distributed, would not harm a crowd: a flame concentrated on one spot could calcify a stone: water would then dissolve the stone, and it would be better for tears to dissolve me utterly than that I should burn of love, without dying . . .

And so, in one sense the beloved burned, robbed and crushed Michelangelo: such would have been the outcome of most intimacy, the emergence of a persecutory object constructed in the image of his own aggression. We wonder, then, at the strength of the hope and reparative power which fed the flame of his passion with constancy, made him generous though miserly to himself, courteous though persecuted, susceptible and humble though of an ingrowing turn of mind, touchy and in some ways self-contemptuous, sardonic and fierce though

wrapped in fear, a supreme creator, believing in himself, who lived to a vast age though unusually committed to negation (cf. Note 23, Part I). Love was burdened with the weight of the beloved, with suffering: he projected as his own this complicated element of attack, into the marble, on the Sistine wall, on paper.

The stock-in-trade of Michelangelo's poetry, we have said, is the Petrarchan lyrical inheritance: Love, Love's dart entering the heart through the eyes, tears, death. But when literary comment is exhausted, Michelangelo's harping upon death, his predicament between love and the good of his soul, his difficulty in distinguishing the good from the bad as well as in combining the good with the bad, the easy entry of the bad into the good, all are very notable. *Fra l'uno e l'altro obbiecto entra la morte* (F. p. 222). (He is referring to the danger for the soul from the obsession of love): 'Death comes between the partners of love.' Yet his suffering, he says many times (e.g. F. p. 124), is a condition of the beauty of the beloved. This conceit too, I think, can be taken in a wider sense than the intended contrast: we have plenty of evidence that the poet insisted upon his melancholy, his ugliness, his badness—*la mia allegrezza è la malinconia*—as a form of well-being, even of happiness (cf. F. p. 160), in so far as they belonged to the only solution possible in one so little blind, the solution by means of that acceptance or recognition which leads on to the restorative activities of art. Michelangelo, in fact, knew that his art depended upon his ability to stomach loss and death, his ability to mourn. This is not to say with certainty that had he been a less afflicted man he could not have been as great an artist. Probably, the danger was always present that he might topple over into complete, listless depression. There is no doubt that he had phases, long phases, when he was too distraught to work. ... Unless overlaid and stifled, we all have sufficient depression at the centre to spur us into continuous

acts of restitution: there is room enough for great artists of an almost sanguine temperament, those who are blithe, those of exemplary orderliness.

One common aspect of dilemma might be summed up as follows in relation to Michelangelo. He was easily possessed and overwhelmed: he thus feared to lose himself: what was taken inside could soon become bad and appropriating: every good thing moved in company with one which was bad, conceived on the analogy of his own aggression, his own greed for the good object, his own anger in the way it frustrated him. These sentences may signify little or nothing. A few illustrations from the poems, however, will allow them a modicum of support. First of all, the good object and a mood of biblical omnipotence.

The sense of the sonnet, F. p. 197, probably addressed to Cavalieri, is as follows: I am more than usually dear to myself: ever since I have had you in my heart, I have felt myself to be worth more, just as the carved stone is of greater value than the block. And just as a piece of paper with writing or a design is of more significance than a blank page, so I have become of value now that I am a target pierced by your beauty. No, I don't regret the assault. On the contrary, the imprint has made me safe: I am like a man with a magic power: I am fully armed: (Cavalieri- = Knight): fire, water, cannot overcome me: in your name I can give sight to the blind and with my saliva I can render all poison harmless.

In another poem addressed to Cavalieri (F. p. 128: much admired by Varchi as by Frey), Michelangelo says: 'With your feet I can carry weight.' He has his being in the beloved: just as the moon has light from the sun, so he possesses a borrowed light. A less comfortable accommodation of the good object may unwittingly be expressed in a madrigal (F. p. 167) addressed to Vittoria Colonna. The sense runs as follows: The empty mould awaits fulfilment from gold or silver liquefied by fire. A perfect work may be taken out of the mould by breaking it. Thus, with

the flame of my love I can cause the shape of empty, unsatisfied desire for your infinite beauty, the heart and soul of my fragile life, to be complete. A beloved woman, far above me, comes down into me through channels so narrow (like those into which the liquid metal is poured) that to bring her out again it would be necessary to break me open, to kill me . . .

It may be objected that whereas this uncomfortable passivity (qualified by the outward passage of tears, cf. F. p. 5) lacks much suggestion of life and well-being, any awkwardness in the images is due either to our scanning them with too literal an eye, or to the nature of the conceit, to an unfortunate variation of a current theme. But suppose the violence of this poem's imagery were the fruit of clumsiness, it would not be the less revealing. Moreover, the violence is surely consonant with the poet's mention of his own death in the ultimate words. The reference is not only conventional, as we know from the majority of the poems which reveal a deep-set depression that Michelangelo himself identifies with death's likeness. He felt empty and his hunger for the beloved was the ache to fill this void (cf. F. p. 111 which ends: Imprint yourself on my thought just as I make use as I please of stone and blank paper. Cf. also F. p. 120: Love commands not only that I feed on you yourself but on anyone whose face resembles yours). But even the good object, suffered with such passivity or entertained with such greed, can become the object of renewed anxiety: in fact, it may become the bad. Otherwise, why should love make him feel robbed, a frequent complaint? F. p. 5 in which he grieves that he is not master of himself, ends thus: O Love, what is this that enters the heart through the eyes: if for a time some of it comes out again (in sighs and tears), the rest goes on swelling inside?

This foetus becomes a source of persecution: the mode of impregnation is always through the eyes: there passes, F. p. 224 tells us again, in an instant to the heart by way of the eyes, whatever object (*obietto*) seems beautiful to them: 'And by way of

this smooth, open and spacious road, there pass not a hundred but a thousand objects of every age and sex.' The poet fears to lose himself: he is now anxious over what he has taken in: all such heterogeneous importations threaten the equilibrium of his soul . . .

The soul, of course, is now the old, original, good object, in contrast with these crowding newcomers who were thought to be supports, who may turn against the good object. It is not difficult to see that the distinction expresses an original doubt concerning the goodness of the good object due to the constant threat from the bad. We read in the tenth of some burlesque stanzas (F. 25–8 and 321): The whole of you enters me through my eyes (fount of tears) like a cluster of grapes thrust into a jar. This cluster, passed through the narrow neck, expands in the belly of the jar. And now that I have you inside me, it seems that you are my pith and marrow: hence I become larger, my body swells as does my heart with your image. I don't think you can get out by the way you came in: the torso is wide but the passage of the eye is narrow. (The version to which Frey gives priority is slightly different. It has the sentence: Your image which makes my eyes weep, grows within me after passing through the eyes.) . . . Part of another stanza is as follows: When air, opening the valve, is forced into a ball, the same air serves also to close the valve from within: similarly, your wondrous image which reaches the soul through the passage of the eyes, by the very manner that it opens them, by the same manner it closes itself within the soul . . .

The impregnation, it is clear, is both pleasurable and a source of some pregnancy discomfort. Remembering the cluster of grapes forced into the receptive neck of the jar, we should, I think, remind ourselves that the infant seizes with his mouth, and in fantasy incorporates, the proffered breast, active in vora-ciousness and greed. It is not, or rather, it is by no means solely, a passive experience. Any glee that may be expressed in the last

lines quoted, has a counterpart in the preceding adumbration of awkwardness. The activity of greed tends to cause the good object to become a bad object, or rather, both greed, and anger at any frustration, summon up the image of a bad incorporated breast against which the good breast must be defended. One defence would be the denial of activity, a protestation of complete passivity, an attribution of badness to the self rather than to the object. The development of this and alternative defences will become exceedingly complicated: and whereas the artist restores, reconstructs the object by his creative work, he must continue to experience also in that defence, traces of the original greed, glee, loss and revulsion, now used to good purpose. The organ about which the processes centre is, of course, no longer the mouth: in the case of Michelangelo it became the eyes.

There are many passages other than those already quoted which express what must be called a genitalization of the act of seeing. Readers will doubtless consider this interpretation unacceptable: at the same time they would find it difficult to-day to overlook the emphasis upon the eyes. There is, of course, a harping upon the eyes as the windows of the soul, and the conventional usages of *occhi* or *ciglia* to indicate the face. (Except in one or two early poems, no other feature of the beloved has even a bare mention.) In Michelangelo's poems, these conventions are much exaggerated. What is unique (cf. *Michelangelo: Poeta*, F. Rizzi, Milan 1924) is the emphasis upon the poet's own eyes, first as a receiving agency, then as an active power whereby to engorge the beloved. Naturally, this second meaning is not openly averred: but, in spite of the passivity experienced, for instance, in the jar-cluster-of-grapes simile, quoted above, it is noticeable that not Love (according to the usual convention), but the loved body or its image enters into the poet. Now, other contexts show that he is by no means entirely passive in his attitude to the beloved body: indeed, the first of the jocular stanzas from which I have quoted, displays an exercise of control

over the beloved, as follows: I believe I love with such faith that even were you made of stone I would be able to make you follow me, more than a step; even were you dead, I could make you speak, and if you were in heaven I would draw you down with complaints, sighs and prayers: but as you are flesh and blood, as you are among us, what limit can there be to expectation? . . .

Yet this active, omnipotent, manic mood passes at once with the transition from stone to flesh and blood. The next stanza (No. 2) begins[6]: I cannot do other than follow you: I don't regret a great undertaking of this kind: for you are not, after all, a rag-doll whose movements inside and out can be controlled. . . . When a day passes (No. 5) without my seeing you, I have no peace: and then when I do see you, I fasten on to you as does a starving man to food, or as another behaves who feels an urgent need to empty his belly . . .

The impression that after all he has treated the beloved in some part of his mind as a rag-doll, as *a puppet of his glance*, subject to the enormity of his every wish, is not reduced if we turn to the curious lines that Michelangelo wrote concerning the mechanism of his own eyes. (F. p. 98. Commentators feel justified in considering these lines to be a description of his own eyes because of the mention there of the yellow flecks that Condivi noted in describing Michelangelo's appearance.) Dobelli (*Michelangelo Buonarroti, Le Rime*, Milan 1932) suggests that the description is meant as a lesson or record of how to paint the eye. Even were it so—and it seems unlikely—we would remain equally aware of a certain complaisance, typical of scoptophilia, in the power to gaze so completely while the seeing eye shows little of itself. The fragment is as follows: The shadow of the eye-lashes, when the eye is contracted, does not impede vision, in fact it is free from one end of the socket in which it turns, to the other. The eye turns slowly beneath the lid, showing very little of its big globe: only a small part is visible of the fount of clear vision. The eye does not move up and down under the

contracted eye-lid which greatly covers it; and the eye-lid since it is not raised, has a shorter arc, with the result that it is less wrinkled when thus stretched over the eye. The white of the eye is truly white and the black blacker than mourning clothes, were that possible; and the yellow flecks that dance between the lashes are tawny. Black, white and yellow occupy the whole socket.[7] . . .

The uses of the eye were especially for Michelangelo a substitute for potency. A sonnet, almost certainly addressed to Vittoria Colonna in her conventual retreat, runs as follows (F. p. 118): My eyes—possibly the 'inner eye' as Frey would have it—have the power to encompass your beautiful face, near or far: but my feet are forbidden, lady, to bring my arms and hands (the rest of my body) where my eyes can go. By means of the eyes the soul, the intellect, are able to ascend to you and embrace your loveliness: but the body, in spite of great love, lacks this privilege because it is heavy, mortal: and since I have no wings I cannot follow an angel in flight: I must satisfy myself with the power of vision alone. Alas! If you exert as much power in heaven as you do here, entreat and obtain that my body shall be changed wholly into one (great) eye, so that there won't remain any part of me which cannot enjoy you. (*Che non ti goda.*) . . .

There is thus described the renunciation of intimacy with so close a mother-figure in favour of long-distance enjoyment and control by the eye: in the very terms of the renunciation, in despair at the absence of wings for flight (sexual intercourse), a cry for the enlargement of scoptophilic pleasure, to embrace all bodily pleasures, all potency.

And so, in terms of the eye, of visual art, thus indirectly, yet always seeking refreshment from the torturing source, Michelangelo re-enacted with greater consistency, with supreme power, with less revulsion, the active and passive consummation of love as well as guilt, greed and their recompense. Harried with inner persecution and with melancholy, he remained

susceptible and aware to the end: it is the first ground of his greatness. *Che chi vive di morte mai non muore*: 'He never dies who lives on that which deals out death.' (F. p. 40.) 'Who would think', he wrote, probably when approaching seventy, 'that dried and burnt wood might become green again in a few days in the light of your beautiful eyes' (F. p. 150)? *I'me la morte, in te la vita mia* (F. p. 50).

The refusals of intimacy to which, among other causes, an excessive sympathy impelled him, were not invariable. Thorny though he was, Michelangelo inspired not only respect but an affection he much valued in a faithful servant such as Urbino or in a tactful and unselfish man as Luigi del Riccio. The latter used to advise Michelangelo's nephew, Lionardo, in the making and timing of little gifts, delicacies, food and wine, which pleased the old man.[8] Since he lived in a considerable squalor[9] that matched his depression and his hardness to himself (he might otherwise have had to entertain his friends), gifts from his relatives and others were nevertheless a morsel of the honouring also due to him, a morsel which he could almost readily accept. He used even to visit del Riccio in the Strozzi Compagna villa and was twice prevailed upon to live out serious illness in the Strozzi house in Rome. Always emotional, he might welcome an old friend with tears of joy; but there was a severe limit to that intimacy, easily ruptured, at any rate for a time. Donato Giannotti, the respected associate both of del Riccio and of Michelangelo, described in his two dialogues about Dante[10] how that at the end of their discussions these close friends were unable to persuade Michelangelo to eat with them. He excuses himself on the grounds that he is more susceptible than any one else of any time: on every occasion that he is among those who are skilful, who know how to do or say something out of the ordinary he is possessed by them, indeed robbed by them (*et me gli do in maniere in preda*): he is no more himself[11]: not only the

present company but any one else at the table would separate him from a part of himself; and he wants to find and enjoy himself: it is not his trade to have much delight and entertainment: what he needs to do is to think about death: that is the only subject for thought which helps us to know ourselves, which may keep ourselves united in ourselves and save us from being dispersed and despoiled by relations, friends, geniuses, ambition, avarice, *etc., etc.*

He was about seventy at the time.[12] It is unlikely that longer, more undeniable court from the powerful has ever been paid to an artist in the flesh; yet he felt distracted from his own essence, even by those who were his worshippers. As, notably, in the cases of the actors, Shakespeare and Dickens, there can be no doubt that the unusual lending of himself (which is also a control of the object) underlay his phenomenal technical command, versatility, and, indeed, originality. For the purposes of art he would initially feel less distrust of the object as he bent it to his will: yet, none the less, in spite of the extraordinary, never-dying warmth of his passionate feelings—extraordinary amid the persecuting fears—love, fascination, interest, entailed oppressive weight, spoliation, a shock to the organization of the ego. He wanted now to keep himself for death, for the undifferentiated, for a merging with what is entire. On the other hand, the separate person 'in his own right', objects good and bad, animate or inanimate, had won from him an overpowering response. (No art, he sometimes says, is sufficient return for the beauty of the object.) And so, he would ever be as the infant with the homogeneous world of the satisfying breast, and he would also be as the rather older infant who could restore, not only this good breast but the self-subsistent mother, the other person, the *whole* separate object whom he had in fantasy overpowered; and he would reconcile or fuse the two ambitions, making the one to serve the other . . .

Such was the constant aim of a supreme artist, and such is the

aim of all lesser artists too. Not many, however, will have employed in comparable degree under the ægis of the restorative æsthetic ideal, psychical trends which when arrayed in strength, must often preclude this lack of emotional simplification, this accessibility, preconditions of the creative refashioning that ends in art.

The superb simplicity or homogeneity of the greatest art which we enjoy as might a starving man a close-grained crust that links every working and sleeping moment, comes to us as an attribute of singularity. Wölfflin has remarked how extraordinary it is that Dawn 'for all her movement can be read as a single plane', that the Medici Madonna and Child combining many tempestuous directions of attitude, give the 'impression of repose because the whole content is reduced to one compact, general form: the original block of stone seems to have been but slightly modified'[13] (Plates 13 and 14). Though all these indications of movement are transverse, the Medici Madonna tapers like a tower with many ledges.

In the combination of the homogeneous with the individual or specific, we have the crux of Form in art, the creed of the artist's endeavour (for which I have indicated some compulsions). There are, of course, an infinity of methods other than Michelangelo's firm resolving of contrasted directions: but his particularly powerful combination of restlessness with repose provide a clear-cut text. All the same, the homogeneous quality is so well fused with the elaboration of an individual content that we cannot separate them. (For instance, both repose and movement speak of the distinctive object *per se*: everything will serve a dual function.) But in spite of the difficulties of analysis, we are well aware in general that, on the one hand, a work of art is an epitome of self-subsistent or whole objects which can neither be superseded nor repeated, an epitome of particular and individual entirety; while on the other hand, striding in upon the

presentation of the concrete, upon the rendering of experience in terms of touchability and the synthesis effected by the eye that perpetuate (in visual art) the image of a separated and outward thing, there comes the tendency to gain for such poignant particularity, connections with everything else, connections that blur, a kinship with the universe, a singleness that vibrates at its junction with the singular; there comes, maybe, the homogeneous experience of the 'oceanic feeling', of sleep, the prototype of death and disciple to the unmatched bliss of the infant at the breast: these contents too are communicated in terms of the senses.

Welded together, they underlie what we call Form in art: that is, they underlie the systems of completeness and harmony which interpenetrate with the many cultural aspects of specific subject-matter on which Form works; in the case of the Accademia Giants, for instance, not only their aspect as Cinquecento nudes but at the heart of the writhing, the theme of conflict in Michelangelo's life.

His figures became more massive and simplified after the early period, without the loss of complicated movement. This deeply-felt simplification rests on the naturalism of the Bacchus and David and Cascina cartoon, upon a rapacious yet self-lending observation, upon a grasp of attitude which is without parallel. He sought the utmost scale and intractability to match the synthesis demanded of his emotion, the utmost carnality to feed his universal maxims, the utmost movement to represent repose, the utmost extensions to serve the centre of gravity. He offered to beauty the ideal settlement, his inherent conflict unified by the character of the marble block; he petrified the body's dynamics of which he was the master; he was of the body as magnificently as he was of death and of God; we soon come upon the genius forcing all the world of sense to serve this angry altar of the nude.

NOTES TO PART III

1 In spite of its name, poetry seems to be the art most apt for the expression of things done to the individual.

2 *Cf.* J. G. Phillips *op. cit.*.

3 Benedetto Croce (*Poesie Popolare e Poesia D'Arte*, Vol. 28 of *Scritti di Storia Letteraria e Politica*, p. 393) says that the four sonnets of two major opposite senses on the subject of Night are a literary palinode, an exercise in the conventional antitheses or set answers of the time. . . . This may be so but it is not merely so. The contrasting identifications with the night reflect a continuous mood of the poet. At a deeper level the contrast barely exists. Much else goes to suggest that night, melancholy, even the thought of death, have for Michelangelo their link with creativeness as well as with eventual calm.

 Croce's general opinion is that Michelangelo was not much of a poet, but that the great Michelangelo does exist in his verse.

4 *Cf.* the epitaph, F. p. 74, for the young Cecchino de' Bracci whose beautiful form is said to animate the artifice of the sepulchre as the soul the body. The last of the four lines is: *C'un bel coltello insegnia tal vagina. Cf.* also F. p. 25, from the burlesque stanzas the lines:

 C'una vagina ch'è dricta a vedella
 Non può dentro tener torte coltella.

5 Some commentators have classed this fragment, also F. p. 108, with the mourning poems for Vittoria Colonna's death. Other critics, however, following Symonds' printing of the Febo di Poggio letter to Michelangelo, in relation with the artist's letter to Febo (M. p. 471), have insisted on the play on the words Febo (Phoebus) and Poggio (summit) in these two poems. For a comment concerning this young man, and for translations of the two letters, *see* Symonds *op. cit.* Vol. II, pp. 154–9.

Symonds points out the extraordinary humility that Michelangelo displayed in writing to the young men, Febo di Poggio and Cavalieri. The artist felt that their appeal entirely outshone his own gifts, so that he was worthless, ugly and bad. It follows that some critics have found Michelangelo's features to be represented in the executed head of Holophernes of his Sistine fresco and in the flayed skin that St. Bartholomew of the Last Judgment holds up, as well as identifying Michelangelo with the position of the vanquished old man on whom the Victor kneels (Palazzo Vecchio).

It was in accordance with Michelangelo's wish, Vasari states, that Leoni's medal of him has on the reverse a figure of a blind man led by a dog. We shall see that to attribute blindness to himself would have been the acme of self-depreciation. (*Cf.* pp. 125–7.)

6 In his commentary Frey considered that at least the first five stanzas as he printed them are consecutive, except that he was uncertain whether his number one or number thirteen should come first. (*Op. cit.* pp. 321–3.)

7 It is perhaps interesting to remark the following though not necessarily relevant detail. Michelangelo concerned himself greatly about the choice of a wife for Lionardo. At the age of seventy-seven he was exercised as to whether or not a particular candidate was shortsighted (*no mi pare picol difetto*, M. pp. 277–81).

8 *Cf.* E. Steinmann. *Michelangelo e Luigi del Riccio.* Florence 1932.

9 It is not necessary to believe the description in his sardonic, burlesque poem (F. p. 86) of the mountains of ordure accumulated by the public at the entrance to his house, in order to appreciate that Michelangelo's domestic surroundings were not only gloomy but verging upon genuine squalor. Coupled with lack of convenience, with austerity and a melancholic sparseness of furnishing, squalor perhaps provides the chief reason for his difficulty in retaining reliable servants. His *Ricordi* show that once at least he engaged a girl with a child in the modern manner (M. p. 605).

10 *Cf. De' giorni che Dante consumò etc., Dialogi di Messer Giannotti,* ed. D. R. de Campos. Florence 1939.

11 *Cf.* especially the activities of the figure of Ludovico—within, Chap. I.

12 He had been more sociable as a younger man: he had sometimes discovered that the feared distraction of social gatherings had separated him from his melancholy (M. p. 446).

13 H. Wölfflin, *Classic Art*, translated from the 8th German edition by P. & L. Murray, London 1952.

I have stressed the fact that early Cinquecento art is the child of Quattrocento art without which Michelangelo's achievement would be unthinkable; and that both are dependants of a growing culture. Wölfflin is the famous guide to this change of style. His analyses in front of early Florentine Cinquecento works will not be surpassed; so, it is excusable that in his constant comparisons he should have belittled, and, indeed, should have disregarded the syntheses effected in the great Quattrocento works. A progression undoubtedly exists from one style to the other in terms of scale, simplification, a larger-handed complexity and, above all, a more avowed homogeneity at the expense of gravity in details, at the expense of a less hurried union whereby exacting homage can be paid to the singularity belonging to each represented object. There is a negative or, at least, an excluding aspect of the Cinquecento æsthetic discoveries, inseparable from the so-called advance. But certainly, Michelangelo's and Raphael's works are the logical peaks in Renaissance art; they rise from a neat earth of cultivated fields and terraces.

Such change of style, dependent directly upon cultural development as well as upon the processes of æsthetic growth, always signifies a changed mode of balance between the two emotional rallying points I have attempted to isolate at the back of Form. Wölfflin has greatly simplified his analysis; the examples he selected of fifteenth-century art in order to contrast them with Cinquecento style, are drawn overwhelmingly from what has been called the Florentine proto-Mannerist style of the second half of the fifteenth century, to the virtual exclusion of those works which in previous volumes I have characterized by the term, 'Quattro Cento'.

Appendices

I

A NOTE ON ICONOGRAPHY

The artist is more faithfully the child of culture, the substitute
father and mother, than the rest of us, because he identifies his
problems specifically with all that surrounds him. He has been
set to serve cultural ideals: the work of art has been a comment
as a rule upon the strength of myth and tradition to this end. A
mature iconography was indispensable, a framework of articula-
tion for the expressiveness of artistic style. Without this popular
poetry to which a thousand approximations in the use of symbol
will have contributed, the artist, bereft of an æsthetic *misè-en-
scène*, finds himself free to-day to employ a less fully related sym-
bolism, potent but transient: whereas the precision of art seems
to demand that much-used symbolism should circumscribe a
personal aspiration. And we do, in fact, still employ as the thin-
nest of frameworks, our long iconographic heritage, now out-
worn. Even so, our iconography tends more and more to
become the iconography of the artist himself. Venus, or more
likely, Œdipus, is a name only, a facetious name that figures in
the catalogue. Hence a necessity, in some modern art for the

hustling, for the rather aggressive dragooning, of Form which must provide shape not only to the means of expression but also to what is expressed; hence our abstract art. (At least, that is one of the determinants. But, of course, all developments in art are over-determined.) And hence the short-lived styles, since the evolution of a systematic symbolism and of a durable style are interdependent processes.

These modern tendencies should not be regarded as regrettable, since we do not know their outcome. Yet it is likely that we must hope that the Machine Age will evolve an iconography and that machines will be domesticated by the imaginative, myth-making power of the community. At present, much of our surroundings suggest that machines have been imposed from without. The artist moves among his various selves: he feels rather blankly omnipotent; the more universal, and even the more personal, his symbols, the more disorientated do they appear to be. It would be unæsthetic to represent vitality by exhibiting a puppy on a leash, or any other piece of living tissue: not altogether dissimilarly, the concentration upon the undoubted essentials of art, whether of Form or of expression, almost the only artistic modes now available, communicate as well as some æsthetic virtue, æsthetic loss; as well as defiance, the cleansing defect in all our lives. We know that true culture is profuse, cluttered with a mass of furniture: it is useless and irritating knowledge.

There has been little monumental art of consequence since iconographic detail began to slacken greatly. A mature iconographic tradition may be narrow, far too narrow: even so, it may, though exceptionally, in terms of a style, communicate to us hundreds of years later, though we have no knowledge except by analogy of its meaning, a beauty, an æsthetic, Form, amassed like folklore. In accordance with the definition of Form, such an iconographic system, whether we can interpret or fully isolate it or not, possesses the familiar air of particularity in combination

with references that extend local flavours to cover all. On the other hand, in such a case we are probably unable to disentangle the personality of the artist.

It will be agreed that an endemic myth may offer to the genius an incomparable stimulus if he is allowed to treat of it broadly. For this reason alone, iconographic studies—and they are very extensive as the work of the Warburg Institute shows—have great importance in the understanding not only of art history but of the *desiderata* for æsthetic creation. Whereas the psychological basis of Form is invariable, a new way of presenting the Last Supper may be tantamount to a new formal conception, and *vice versa*. Scope for the artist's personality, varying with the character of the iconographic pattern (which is interdependent with what is called style) will be severely limited by an iconography so hieratic as to resist variation.

Such was by no means the case in the Renaissance, as everyone knows; yet iconographic reference was still meaningful, robust. We are likely to envy Michelangelo his opportunities when we learn, for instance, of his David that 'another source of inspiration which explains the accentuation of the difference of the two sides, right and left, one being strong and on guard, the other open and unprotected, is found in the symbolic sense given to the two sides as far back as antiquity. Antique myths explained the right side as masculine and active, the left as feminine and passive. . . . The Middle Ages has a theological interpretation: the right side is protected by God, the left is weak and exposed to evil' (Tolnay, Vol. I, p. 155). Tolnay describes the affinities that had grown up between the current conceptions of David and Hercules: more than one iconographic lineage is detected in Michelangelo's figure. How different, we exclaim, from the fancies by which modern artists hope to attach their conceptions to the recurring symbols that have stood the test of time.

The Renaissance reunited the classical motifs with the classical

themes: in the Gothic age, the themes had had no classical treat-
ment, and the classical motifs were applied to Christian subjects
(E. Panofsky, *Studies in Iconology*, New York, 1939). It follows that
the motifs, reunited in the Renaissance with classical themes,
brought with them a wealth of medieval iconography. On the
other hand, some religious themes were given a classical
imprint. Panofsky instances an equation of St. John with
Ganymede (the rise of Mind to God).[1] As far back as the trouba-
dours there existed an attempt to reconcile *cupiditas* with *caritas*,
comparable to the reconciliation of classical and medieval prin-
ciples in High Gothic statuary and Thomistic theology
(Panofsky).

The Renaissance was an age of elevated yet earthly and
equivocal convictions. What a triumph it is that in Titian's Sacred
and Profane Love, the fine, healthy nude symbolizes the Sacred
Love, the clothed woman, the Profane. This iconographic theme
is perhaps unexpected, but the pensive fullness of Titian's paint-
ing is very apparent. Similarly, we are well aware, without any
precise knowledge of Neoplatonism, let us say, we are aware that
many of Michelangelo's nudes are bemedalled with the light of
an enamoured philosophy whereby guilt and other unconscious
material achieves the air of epic poetry.

I am thinking of the presentation drawings for Tommaso de'
Cavalieri which Michelangelo sent to him in the first year of his
love. The correspondence shows how unworthy Michelangelo
felt himself to look into those eyes, how presumptuous; and it
was to honour Cavalieri, as a token of *physical* self-effacement,
that he made first the drawing of Ganymede (copy at Windsor)
borne aloft on the back of the eagle with the bird's neck

[1] Sebastiano del Piombo suggested to Michelangelo that a fresco of Ganymede
would look well in the lantern of the Medici Chapel cupola. If Ganymede, he
wrote, was given a halo, he would serve as a St. John of the Apocalypse being
borne to heaven (Milanesi, *Les Correspondants*, p. 104).

stretched around the torso, expressive, according to Tolnay, of 'mystic union and rapture'. We may well feel to-day that propriety was never again to be less arduous. In this life-giving presumption that beauty spiritualizes, iconographic luxuriance has played an important role. By and large, art requires of unconscious bents that they be poetized. There has never been a more careful vehicle than the Greek myths. Michelangelo's fear of presumption *vis-à-vis* Cavalieri led him to make for him three drawings of the Fall of Phaethon. (At least one is a rejected version, but all three were probably seen by Cavalieri, cf. A. E. Popham and J. Wilde, *Italian Drawings at Windsor Castle*, London 1949. Wilde (1953) now considers the unfinished Venice version as the later.) Although Jupiter takes the place of Apollo, Phaethon's father, in hurling the thunderbolt that destroys Phaethon and his borrowed equipage, we know to-day beyond dispute that the primary meaning of this story expresses the male child's castration fear, the result, as he feels it, of his own presumption. Cavalieri figures more than once in Michelangelo's poems as the sun. It is he, too, the Rider, astride a now subservient eagle, who hurls Michelangelo to destruction (cf. the Febo di Poggio poems). One aspect of the relationship with Cavalieri, I would suggest, was Michelangelo's regard for him as a parent[2] calling forth the truly sincere expression of his own unworthiness to the boy. Even in this great ardour that revived the ageing artist, we come upon the passive component of his passion, both preferred and dreaded. The figure of Sensuality in the Last Judgment (for copies, cf. Wilde 97 and 98) sucks the fingers of one hand while the back of the other is pressed against the base of his spine. In the Bacchanal of Children, another presentation Cavalieri drawing at Windsor, expressive of infantine licence, we may see in the bottom left-hand corner the actions which both

[2] In a letter to him Michelangelo speaks of Cavalieri's name (Knight, presumably visualized with sword or spear) as the food on which he lives. M. p. 468.

these gestures represent, treated directly yet nevertheless disguised in one case by their combination itself.

The Windsor drawing of the predicament of Tityus, yet another presentation to Cavalieri, doubtless symbolizes the agonies of sensual passion (Panofsky, Wilde, Tolnay). It should also be remarked that this pain is inflicted by so punitive a phallic emblem (the vulture), and we should remember this in contemplating the assault upon the stone herm in the famous Archers drawing (Windsor), Plate 7, though the mood is different: the Herm receives imperviously the manifold attacks of what is, we are made to feel, an irresistible power. 'I live off my suffering', wrote Michelangelo. It was desirable that the stone, hacked by the sculptor, should give proof of the same irreducible kernel.

Michelangelo's Bacchanal of Children is the apotheosis of the putto theme, of unconscious passion and fury in an 'innocent' form, of the fruitful prisoners of civilized living to whom the artist, as gaoler, allows exercise in a rather less confined air. During the Quattrocento, putti were shown seething in marble relief, angels, dæmons, or merely infantine incorrigibles. The Quattrocento enlarged the elemental role derived from the Antique so that we come to see it as the basis of profusion, as the broad acceptance of deeper psychical reality from which art springs. No matter that Michelangelo uses the putto here to demonstrate everything pernicious: his judgment did not exclude his gusto. But it will be different in the age of the Counter-Reformation into which he passed.

His work celebrated both the end of the Quattrocento and the beginning of several new trends in art, the most permanent of which, still pre-eminent to-day, we recognize, for its accent upon individuality-cum-infinite-longing, as the basis of Romantic styles. When culture is most subject to hierarchical restraints,

the personality of the artist is least distinguishable. Art was rich-est, however, when the commanding influences, including a rampant iconography, were various, cross-grained yet suf-ficiently harmonious to avoid for a time the relaxation of a dominant tone.

The iconography of the Sistine ceiling stems principally from the Old Testament. The difficulties arise when commentators, dumbfounded by the novel, unified treatment of biblical char-acters, search for a master theme. However necessary it may be, such a search is likely to be less rewarding in the case of visual art than in the case of literature where this kind of literary criti-cism is naturally more at home. A complicated philosophical programme accords ill with the need for contrast, proper to visual art, or even with the difficulties of fresco painting. Is it imaginable that the artist of the Sistine ceiling, confronted with the problems of the site, requiring a bold decorative effect from the whole, could have undertaken at the same time an icono-graphic programme that demanded cumulative philosophical references for every gesture of each figure? It is a commentary on the iconological science when so applied, that the most idyl-lic of all paintings, Giorgione's *Tempesta*, probably holds the record, in relation to its size, for volumes largely devoted to an iconography of every detail, whose sum in each case provides arguments proper only to a thesis.

That is an extreme instance: moreover, the painting requires iconographic interpretation. But I do not think there is further need for the philosophical variety in the case of the Sistine dec-oration. The access of strength brought recently by Tolnay (*op. cit.* Vol. II) to the school of interpretation that favours a Neoplatonic programme, whereby he interprets the gesture of the least atten-tive attendant *putto*, is not, in my opinion, sufficiently rewarding. There must be some difficulty in the consistency of lower and higher spheres as the basic subject-matter, when *all* is treated by

the artist in a heroic vein. This difficulty is less apparent, perhaps, in the Sistine ceiling (although the ignudi present a hurdle) than in the Medici chapel: as Hartt pointed out in his review of Tolnay (*The Art Bulletin* 1950), according to his (Tolnay's) scheme, the very altar figures in the realm of Hades. (If the *Magnifici* tomb had been executed, the Virgin would have been placed on a level with the doors' tabernacles, rather higher than she is to-day, but not in Tolnay's celestial regions.) I find a similar difficulty in the great Panofsky's Neoplatonic interpretation of the earlier Julian tomb projects. The seated Moses on the platform would have had for Panofsky an expression of supernatural excitement enrapturing the soul of a super-man, whereas the Slaves or Captives below were to be the expression of animal nature. Is it churlish to comment that in fact the Slaves of the Louvre appear more spiritual than the Moses of San Pietro in Vincoli?

Partly so. We have seen that at this time the reparative function of art tends to ennoble all. It is likely there was at any rate a vague programme of the kind that Panofsky envisages. What we know of Michelangelo's inner struggle is consonant with the antithetical intimations of such programmes by Panofsky, Tolnay and others. In Michelangelo's largest works, Neoplatonic abstractions may have served as an exordium, exciting the vision of the artist. Even vague sentences of the patron, certain only of his importance, his personal myth, his culture, could sometimes have had a similar effect. Indeed, I incline as much, it will have been evident, to an emphasis on the culture and ambition of the patrons, on the attitudes of Michelangelo, as far as they may be discerned or deduced, towards those who commissioned him.[3]

[3] According to H. B. Gutman (*Franciscan Studies*, 1944 and 1953) a prime iconographic source for the Sistine decoration was the then popular commentary on the Scriptures by the Franciscan, Nicholas of Lyra. Gutman's overall interpretation is less strained than those of the Neoplatonists.

II

THE MEDICI CHAPEL

There may be some readers for whom it would not seem too far-fetched were it supposed that the antiphonal Allegories (Plates 14–18) on each tomb in the Medici chapel imply among their other meanings a disrupted intercourse, that under this image Michelangelo harboured throughout life the evil done to the well-loved original object, the mother or mother-surrogate. His ways as a rule were not those of separation and denial: love summoned the thought of attack: the images projected by his art needed heroic encasement. At the same time there is evidence in his work of a profound belief in the beneficence of the masculine power,[1] in an overruling and forthright omnipotence which was not, however, employed for the mere denial of his inner

[1] I have referred to Michelangelo's suffering from stone (Chap. I, Note 1) but I have not mentioned the expression used by Condivi, repeated by Vasari, of the gaining of the propensity for sculpture from his foster-mother's milk. According to them, Michelangelo said he drew in the instruments of sculpture, chisel and mallet, from the foster-mother, wife and daughter of stone-cutters. Cf. note on Cavalieri's name, p. 140.

problems (otherwise he would not have been an artist). Thus, he did not abrogate through this means the hurt associated by the infant with the parents in each other's embrace. On the contrary, he was able to sublimate and idealize this murderous scene with its own ferocious strength, when he carved in relief the battle of Lapiths and Centaurs. Some thirty years later in the Medici chapel he created an ideal vision of the depressive root, the loss of the self-contained object, an event that was suffered before the image of destructive intercourse had hardened it. The phallic woman emerged fully from this last hideous scene, cluttered up, one might say, throughout the flaccid length of her body with a surfeit of destructive phalli to which her protuberances bear witness, and even her Gorgon hair. Such is the suffering, surfeited yet beautiful figure of Night: there is conveyed to us by means of the æsthetic sublimation both the sense of gross surfeit and of surfeit overcome. But in life as opposed to art, Michelangelo was unable to find for his emotions a formula whereby to accept the heterosexual embrace. He needed to turn from the hidden incalculable, uncounted evil within the woman (who lacked Vittoria Colonna's aristocratic manliness), to the measurable maleness of the male, to the good version of a vital source, which he served as if *he* were the woman to be cured by it: the scenes of frightful intercourse were within him.

And so, in the deeper layers of his mind, man is also woman for him, the good maleness and the cleansed creative woman, while the woman is the bad man, in the sense of enclosing within her a male putrefying power. Hence the coincidence of active and passive elements which Michelangelo idealized with such force in his art; hence the subjection to his father, whom he upheld by putting forth all his strength; hence the statue of the Victor, a young man who kneels on the back of a completely passive old man whose features have sometimes been roughly identified with those of Michelangelo himself. (It was proposed, immediately after his death, to use this statue for his tomb.)

Of course, the hope of a healing heterosexual intercourse was never entirely abandoned, nor the revolt, often practised—it gave rise to the central conscious conflicts of his life—from the tyranny of the father-figures whom it had been necessary to wed. Does not the hacked stone reveal a rejuvenated form; might there not be some white power that could overcome the ceaseless disruptive parental intercourse that went on within? Several copies of Michelangelo's Leda have survived. A tyro in these matters can sense that here the swan is an all-enveloping phallic symbol of singular power. Since Leda is of the stuff of the surfeited Night—the source for both is the same—one may add that the swan is meant to achieve the curative act which is felt to be beyond the power of any man. Night's predicament demanded it; Leda would give birth to the twin heroes, the Dioscuri.

The period of the Medici chapel and of the Leda when Michelangelo was in the early fifties, became a time of utmost depression and of physical exhaustion. It has been called his erotic period as an artist. War, the complications of his dealings with the Medici Pope, now in distress, the death of his brother Buonarroto, the weakness of his father followed by his death, the uncertainty of the times and of his own affairs, some personal danger even, enlarged this emotional constellation. He turned eventually to the reinforcement of the old defence. In 1534, he finally abandoned his beloved mother-city, Florence, now in the hands of the dangerous tyrant, Alessandro, and the unfinished Medici chapel, for Rome, for the Popes, for Tommaso de' Cavalieri.

INDEX

Routledge Classics
Get inside a great mind

Leonardo da Vinci
A Memory of his Childhood
Sigmund Freud

'Freud's *Leonardo* changed the art of biography forever. Henceforth none would be complete without a rummage through the subject's childhood origins.'
Oliver James

The ultimate prodigy, Leonardo da Vinci was an artist of great originality and power, a scientist, and a powerful thinker. According to Sigmund Freud, he was also a flawed, repressed homosexual. The only biography the great psychoanalyst wrote, it remained Freud's favourite composition. The text includes the first full emergence of the concept of narcissism and develops Freud's theories of homosexuality. While based on controversial research, the book offers a fascinating insight into two men – the subject and the author.

Pb: 0–415–25386–1

Totem and Taboo
**Some Points of Agreement between the Mental Lives of
Savages and Neurotics**
Sigmund Freud

'With *Totem and Taboo* Freud invented evolutionary psychology.'
Oliver James

Widely acknowledged to be one of Freud's greatest cultural works, when *Totem and Taboo* was first published in 1913, it caused outrage. Thorough and thought-provoking, *Totem and Taboo* remains the fullest exploration of Freud's most famous themes. Family, society, religion are all put on the couch here. Freud's theories have influenced every facet of modern life, from film and literature to medicine and art.

Pb: 0–415–25387–X

For these and other classic titles from Routledge, visit
www.routledgeclassics.com

Some titles not available in North America

Routledge Classics
Get inside a great mind

Écrits
A Selection
Jacques Lacan

'Lacan's work marks a crucial moment in the history of psychoanalysis, a moment which will perhaps prove as significant as Freud's original discovery of the unconscious.'
Colin McCabe

Écrits is Lacan's most important work, bringing together twenty-seven articles and lectures originally published between 1936 and 1966. To this day, Lacan's radical, brilliant and complex ideas continue to be highly influential in everything from film theory to art history and literary criticism. *Écrits* is the essential source for anyone who seeks to understand this seminal thinker and his influence on contemporary thought and culture.

Pb: 0–415–25392–6

Dreams
Carl Gustav Jung

'He taught himself how to read the language of dreams as if they were the forgotten language of the gods themselves.'
Laurens van der Post

In this revolutionary work, the visionary thinker Carl Gustav Jung examines the meaning and function of our dreams and argues that by paying proper attention to them and their significance we can better understand our inner selves. He believed that dreams are the 'most common and most normal expression of the unconscious psyche' and therefore provide the 'bulk of the material for its investigation.' This edition comprises Jung's most important writings on dreams and as an overall survey of the subject it is without parallel.

Hb: 0–415–26740–4 Pb: 0–415–26741–2

For these and other classic titles from Routledge, visit
www.routledgeclassics.com

Routledge Classics
Get inside a great mind

Science of Mythology
C. G. Jung and Carl Kerényi

'Jung was probably the most significant original thinker of the century.'
Kathleen Raine

This book investigates the authors' contention that an appreciation of mythology is crucial to an understanding of the human mind. It argues that ancient myths were built up from primordial images carried within our unconscious, reflecting ancestral experiences common to us all. Myths surround us today as much as they did in classical times, making this the perfect guide for those who want to unearth their significance and gain an insight into their own predicament.

Hb: 0–415–26743–9 Pb: 0–415–26742–0

Romantic Image
with a new epilogue by the author
Frank Kermode

'In this extremely important book of speculative and scholarly criticism Mr Kermode is setting out to redefine the notion of the Romantic tradition, especially in relation to English poetry and criticism . . . a rich, packed, suggestive book.'
Times Literary Supplement

One of our most brilliant and accomplished critics, Frank Kermode here redefines our conception of the Romantic movement, questioning both society's harsh perception of the artist as well as poking fun at the artist's occasionally inflated self-image. Written with characteristic wit and style, this ingeniously argued and hugely enjoyable book is a classic of its kind.

Hb: 0–415–26186–4 Pb: 0–415–26187–2

For these and other classic titles from Routledge, visit
www.routledgeclassics.com